POSTCARD HISTORY SERIES

Nashville

Nashville

Scott Faragher

ARCADIA
PUBLISHING

Published by Arcadia Publishing
Charleston SC, Chicago IL, Portsmouth NH, San Francisco CA

Printed in the United States of America.

Library of Congress Catalog Card Number: Applied for.

For all general information contact Arcadia Publishing at:
Telephone 843-853-2070
Fax 843-853-0044
E-Mail arcadia@charleston.net
For customer service and orders:
Toll-Free 1-888-313-2665

Visit us on the Internet at www.arcadiaimages.com

This book is dedicated to Robert Ryan and Jack Kershaw,
two native Nashvillians, historians, and friends,
who have made their own marks
on Nashville.

CONTENTS

ACKNOWLEDGMENTS

First and foremost, my thanks to Katherine Harrington for her tireless search for the right images. Also thanks to Terry Calonge and all the folks at Southern Postcard Company of Goodlettsville. They have been providing some of Tennessee's best postcards for nearly half a century. I would also like thank Gibson Musical Instruments. Since Gibson Guitars moved to Nashville in 1976, the company has made many significant contributions to Nashville's music, social, and architectural scenes. Under the skillful direction of Henry Juszkiewicz and David Berryman, the 100-plus-year-old company has become a significant player in the Music City, as well as the rest of the world. In addition to Gibson Guitars, Mapex Drums, Dobro, Oberheim Keyboards, and other internationally famous brands, the company also produces a full range of stringed musical instruments under the Epiphone banner. Gibson also operates Cafe Milano and the Gibson Cafe, two of the city's favorite entertainment venues, both located in restored buildings in the heart of the Downtown Historic District. More importantly, Gibson supports and encourages musicians and entertainers nationwide.

INTRODUCTION

Nashville has had many names in its 200-year history. Today, it is internationally known as "Music City, U.S.A.," a title it has certainly earned. But other names, especially those from the past, such as "Gateway to the South," "City of Rocks," and "Athens of the South," are each appropriate in their own way. The images presented here portray a Nashville other than "Music City," a Nashville of a bygone time, when life moved at a slower pace, and was somehow grander and more elegant. This is apparent in the grace and magnificence of Nashville's lost architecture. In fact, most of the scenes presented here in the form of postcard images no longer exist. For example, some hotels, such as the famous Maxwell House, Andrew Jackson, and Sam Davis, no longer exist. Others, such as the Noel and James Robertson Hotels, still exist physically, but their buildings have been put to other uses. Sadly, Nashville has lost most of its great houses, all downtown mansions, save one, and nearly all of Church Street, the city's once prosperous retail center.

This was not always so. According to traditional history, Nashville was founded on Christmas Day, 1779, when James Robertson and a small group of men crossed the frozen Cumberland River and set up camp on the bluffs at a location that is now First Avenue North. Surveyor Thomas Malloy later designed the city, which at the time was bordered by Jo Johnston on the north and Broadway to the south. The Cumberland River provided the city's eastern border, and Nashville continued west as far as Ninth Avenue. By 1880, a century later, Nashville had not only become a city, but had seen the establishment of several major railroads, joined and left the Confederacy, witnessed the birth of Vanderbilt University, Fisk, and Meharry Medical College, become the State Capitol, and established itself as a significant commercial center.

As the population increased, churches, religious colleges, public buildings, hotels, parks, bridges, and commercial properties flourished in this expanding environment, and Nashville reached its zenith in terms of classical architecture. Over the years, however, Nashville suffered a series of unfortunate disasters that seem almost Biblical in proportion. Nearly 70 city blocks of East Nashville's finest homes and buildings were destroyed in one afternoon by a freak wind-driven fire in 1916. On Christmas Night in 1961, flames destroyed another landmark when the century-old Maxwell House Hotel caught fire. The wonderful Victorian-era Tennessee State Fairgrounds burned to the ground on the night of September 20, 1965, while the Tennessee State Fair was in progress. What remained of the William Gerst Brewery succumbed to fire in the early 1990s.

Other destruction of great buildings and residences continued throughout Nashville's history. The misguided policy of urban renewal swept away blocks and blocks of remaining buildings in the early 1950s. Houses were demolished along West End and Elliston Place in favor of office buildings. By and by, these newer buildings met the same fate themselves, in favor of wider streets and taller buildings.

Today, however, Nashville has been reborn, and it thrives at an unprecedented level. Ironically, the focal point of Nashville's revitalization is once again downtown, at the river front on First and Second Avenues, where Nashville began. For those who have grown and matured with Nashville, these postcards and photographs will rekindle many fond memories. For those new to the Music City, or those wishing to see what old Nashville was like, these images will perhaps open a window to the past.

One

GREETINGS, NASHVILLE AND CUMBERLAND RIVER

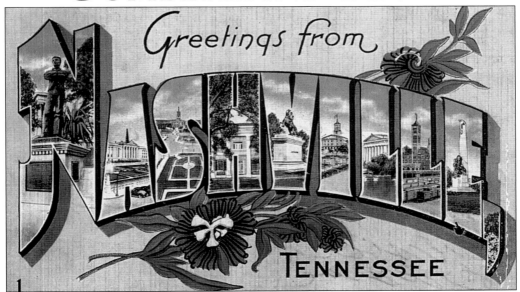

GREETINGS FROM NASHVILLE, TENNESSEE. The following three "Greetings" cards are typical of those found in most American cities during the first half of the twentieth century. This 1940 "Greetings from Nashville" card features local scenes including the Sam Davis Monument, the War Memorial Building, Memorial Square, the Hermitage, Jackson Monument, the State Capitol Building, the Parthenon, Union Station, and the Peace Monument, all significant Nashville landmarks.

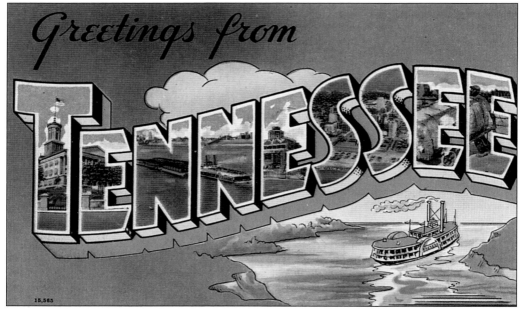

GREETINGS FROM TENNESSEE. "Greetings from Tennessee" shows familiar Tennessee scenes placed within the various letters on the card, including the familiar State Capitol Building, barges in transit, and a sidewheeler steamboat. Technically, both of these boats could be traveling either the Tennessee, Mississippi, or Cumberland Rivers.

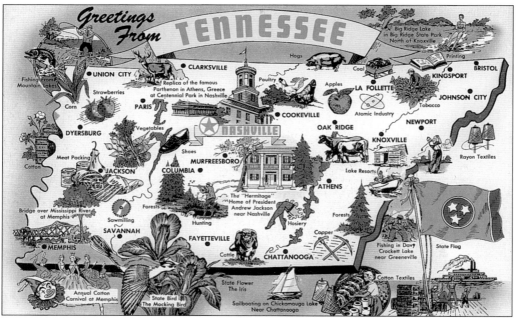

GREETINGS FROM TENNESSEE. This last card from 1960 depicts places, activities, events, and items of interest throughout the state, including the state flag, state flower (iris), state bird (mockingbird), and Andrew Jackson's home, the Hermitage. On the back of the card, the state population (as of 1960) is listed as 3,567,089.

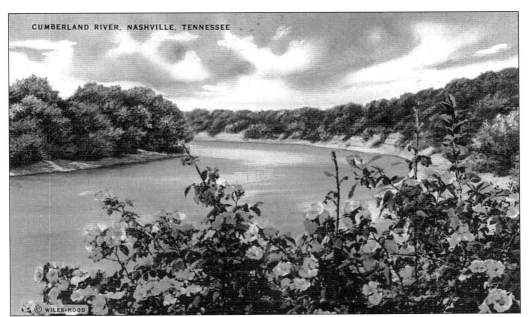

CUMBERLAND RIVER. The first European settlers made their way to what would eventually become Nashville by way of the Cumberland River. The Cumberland River is the smallest of Tennessee's three major rivers. Today in Nashville, it serves as the water route for Opryland Hotel's river taxis, as well as for commercial and pleasure boating.

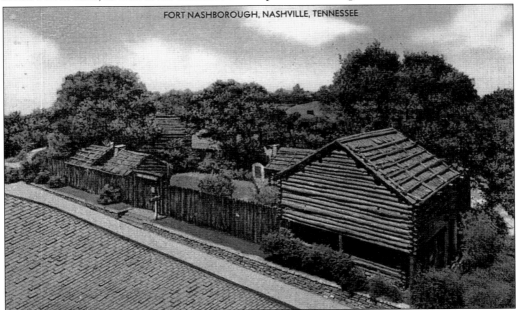

FORT NASHBOROUGH. This postcard dated 1938 shows Fort Nashborough as it stands today on the banks of the Cumberland River in downtown Nashville. In 1938, this full-size model of the fort was constructed on the original site in honor of the 150th anniversary of the city's founding. The first settlers endured brutal weather, harsh conditions, and constant danger from attacking American Indians.

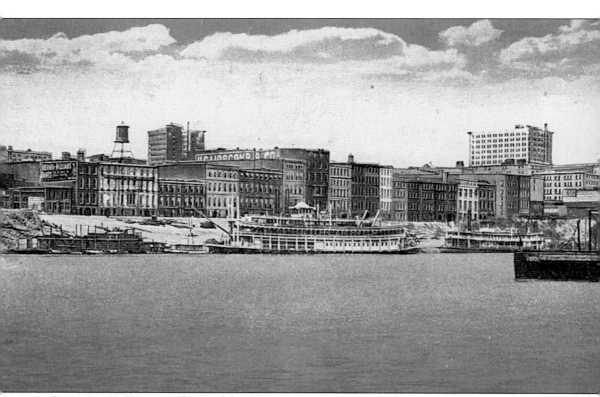

CUMBERLAND WHARF. This card from 1921 depicts the Cumberland River Wharf, now known as Riverfront Park, as it appeared at the time the card was printed. The lower row of buildings pictured are still there today, forming the rear wall of the buildings on Nashville's historic Second Avenue, the city's hot tourist area. In fact, the dark, four-story building visible at the far left of the card now houses the Hard Rock Cafe.

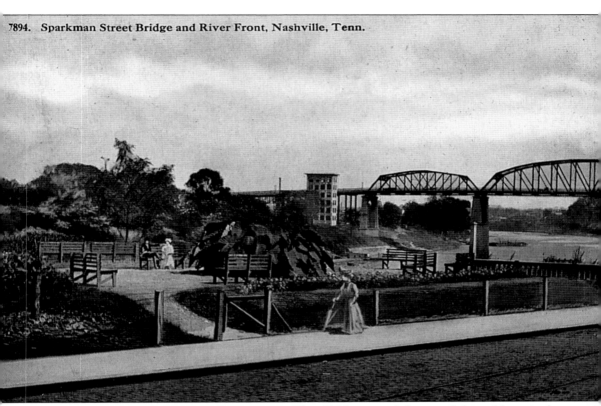

SPARKMAN STREET BRIDGE AND RIVERFRONT. This 1912 postcard shows a fashionably attired woman walking on a sidewalk, a tranquil park to her right, the cobblestone street to her left, and the bridge and river to the far right. The majority of Nashville's original streets were made of cobblestones. These hand-hewn stones served as ballast in the sailing ships that crossed the Atlantic Ocean from Europe. Today, cobblestones can still be seen in certain older parts of town where the asphalt has worn thin over time.

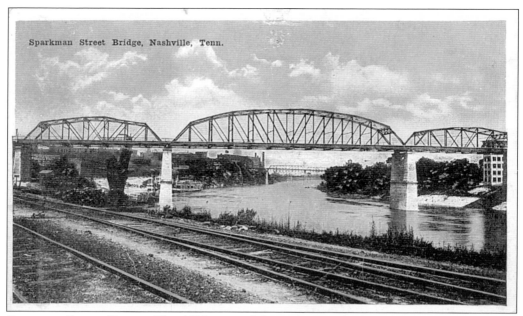

Sparkman Street Bridge, Nashville, Tenn.

SPARKMAN STREET BRIDGE. This 1923 postcard shows the same bridge spanning the Cumberland River, but viewed from the south. It is interesting to note the change in scenery from rural to rail in the same general area in such a brief period of time. This bridge was renamed the Shelby Street bridge.

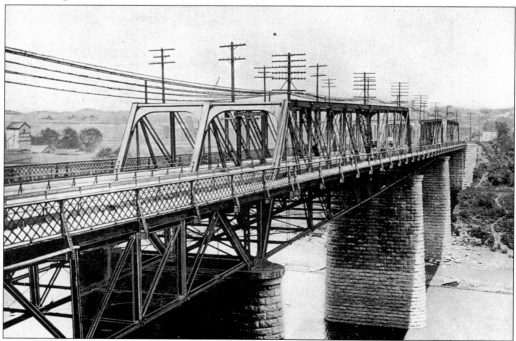

BRIDGE OVER THE CUMBERLAND RIVER. This bridge spanning the Cumberland River stood north of the Sparkman Street bridge, less than half a mile in the distance. It has long been rumored that giant catfish live at the base of all Cumberland River bridge pilings.

Two

Civic Nashville

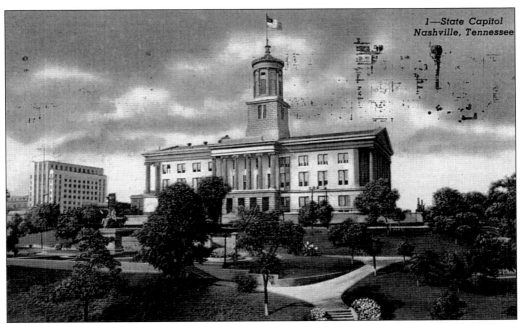

State Capitol, Nashville, Tennessee. This 1953 view of the State Capitol Building shows the intrinsic natural beauty of the site, which is perched 197 feet above the Cumberland River. Prominent period architect William Strickland, who died prior to its completion and is interred within the building's walls, designed the classic Greek Revival building. The cornerstone was laid in 1845, and the building was completed on March 19, 1859.

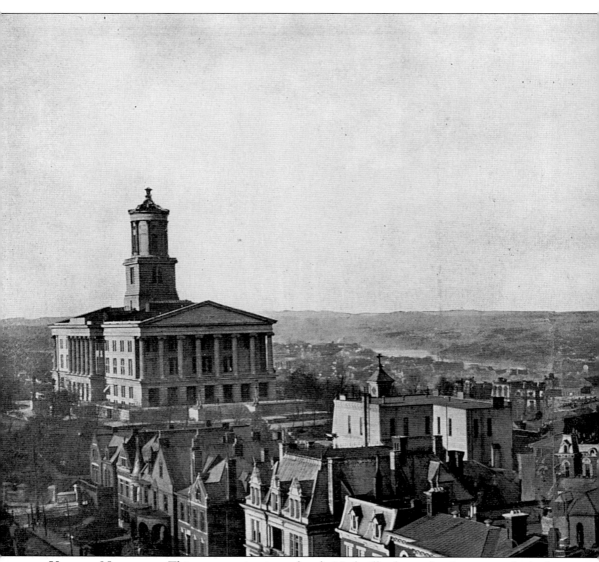

VIEW OF NASHVILLE. This panoramic view of early Nashville shows the degree to which the State Capitol Building dominated the early Nashville skyline. As can readily be seen, Nashville

had some incredible architecture at one time. Sadly, less than five of the buildings and residences pictured here remain today.

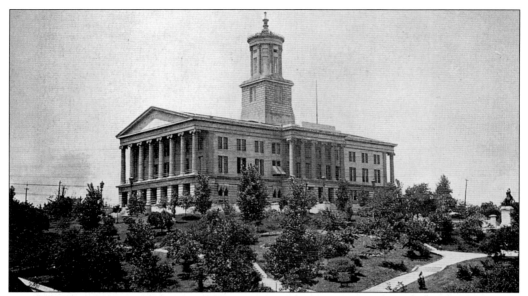

STATE CAPITOL. This alternate and earlier view of the State Capitol Building shows the grounds in their former configuration. Note Jackson's statue to the far right. Today, many of the trees are gone and the building is surrounded at its base by an asphalt parking lot for state employees. Despite the absence of trees, however, the grounds are manicured and very well maintained, and the open space on the north side provides an incredibly impressive view of this remarkable structure.

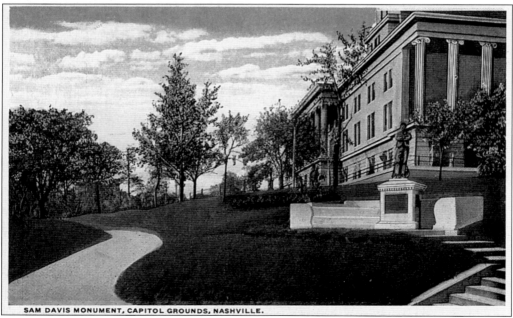

SAM DAVIS MONUMENT, CAPITOL GROUNDS, NASHVILLE.

SAM DAVIS MONUMENT, CAPITOL GROUNDS. This scene of the Capitol Building shows the grounds and a monument to Confederate hero Sam Davis, who, when captured by invading Union forces, chose death over betrayal of his compatriots. At the age of 21, he was hanged by Union invaders near Pulaski, Tennessee, in November 1863.

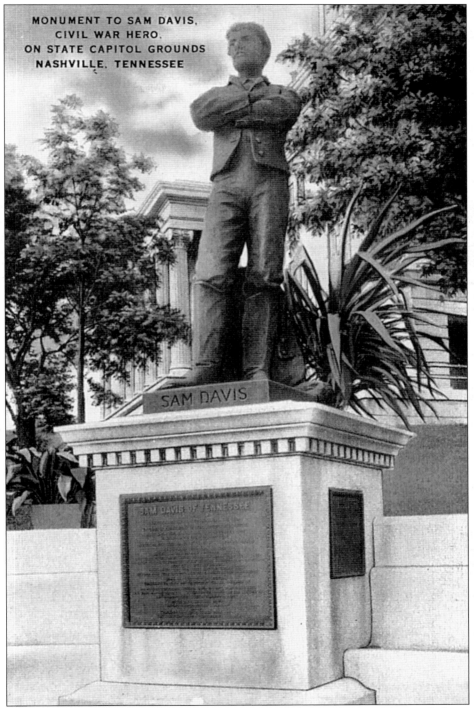

MONUMENT TO SAM DAVIS,
CIVIL WAR HERO,
ON STATE CAPITOL GROUNDS
NASHVILLE, TENNESSEE

SAM DAVIS

SAM DAVIS OF TENNESSEE

CLOSE-UP OF SAM DAVIS MONUMENT. This close-up of the Sam Davis Memorial shows the young Confederate hero, a native Tennessean. This statue was created by the famous sculptor Zolnay and dedicated in 1909.

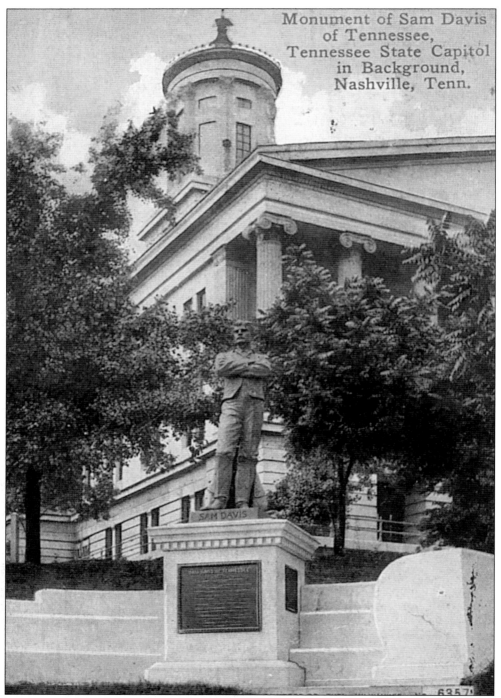

Monument of Sam Davis
of Tennessee,
Tennessee State Capitol
in Background,
Nashville, Tenn.

SAM DAVIS

6357

MONUMENT OF SAM DAVIS (STATE CAPITOL IN BACKGROUND). This 1910 postcard photo shows the Sam Davis Monument, but more importantly it shows the Capitol Building's tower, as well as its impressive columns.

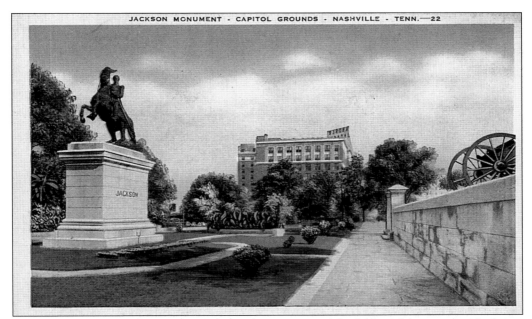

JACKSON MONUMENT, CAPITOL GROUNDS. This is a view of the Jackson Monument, which was dedicated during Nashville's centennial celebration in May 1880. It is located on the State Capitol grounds. Visible in the distance is the former Andrew Jackson Hotel, and to the right side is a cannon. Through the 1950s, there was a cannon and even a Gatling gun on the Capitol Grounds. To the right and up on a hill (but out of view) is the Capitol Building.

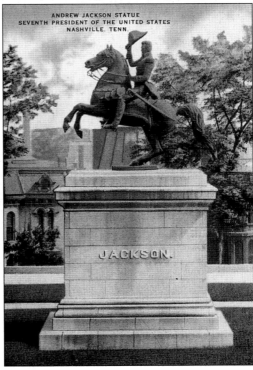

CLOSE-UP VIEW, JACKSON MONUMENT. If this mounted statue of Andrew Jackson looks strangely familiar to you, you've probably seen an identical one in Jackson Square, in the heart of the famous New Orleans French Quarter in front of the St. Louis Cathedral. There were three identical casts made of this 20,000-pound statue by sculptor Clark Mills. The third is near the White House in Washington, D.C. What is particularly interesting about this postcard is the old mansions in the background, which have long since been replaced by other structures.

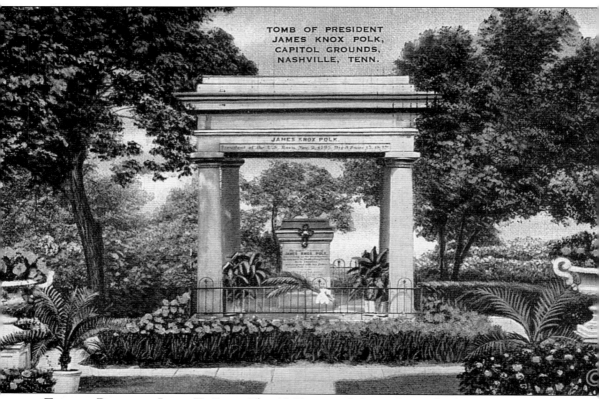

TOMB OF PRESIDENT
JAMES KNOX POLK,
CAPITOL GROUNDS,
NASHVILLE, TENN.

JAMES KNOX POLK.

TOMB OF PRESIDENT JAMES K. POLK. This 1945 postcard shows the tomb of our nation's 11th president, James K. Polk, and his wife, located on the State Capitol grounds. His remains were originally interred at the Old City Cemetery but were subsequently moved to the Capitol grounds.

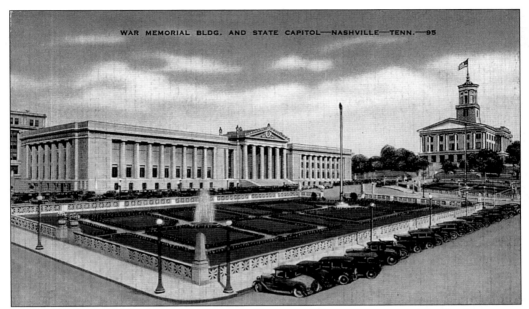

WAR MEMORIAL BUILDING AND STATE CAPITOL. This area was originally known as Memorial Square, and consisted of the War Memorial Building, the courtyard and fountain, and the State Capitol Building. During the 1960s, the city's main local bus stop was located under junky looking shelters running the length of the courtyard, the site where the cars appear in this picture.

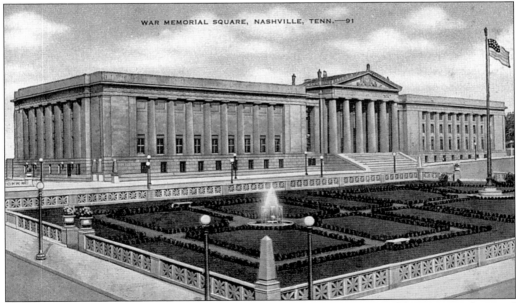

CLOSE-UP, WAR MEMORIAL BUILDING. In 1925, the War Memorial Building was constructed jointly by the City of Nashville and Davidson County as a memorial to soldiers of all wars. Located to the left, but out of the picture, are two large statues, one of which honors the Confederate Womanhood of Tennessee. The building houses the 2,000-seat War Memorial Auditorium, a gigantic bronze statue of Victory, and the State Military Museum.

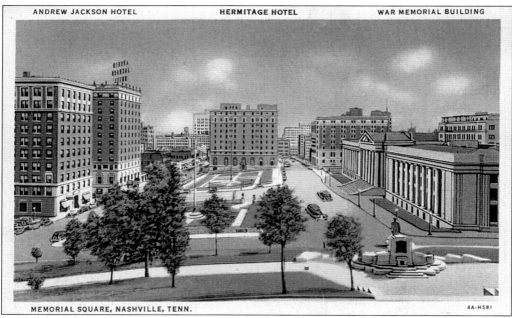

MEMORIAL SQUARE, NASHVILLE, TENN. 4A-H581

MEMORIAL SQUARE FROM STATE CAPITOL BUILDING. This view, presumably from the Capitol steps, shows the War Memorial Building to the right, the Hermitage Hotel (still in operation) in the center distance, and two other buildings to the far left, both of which are now gone. Pictured second from the left is the Jackson Hotel. The courtyard in the center of the postcard has been replaced by a subterranean parking lot and covered with steps and a cement plaza, and is now called Legislative Plaza.

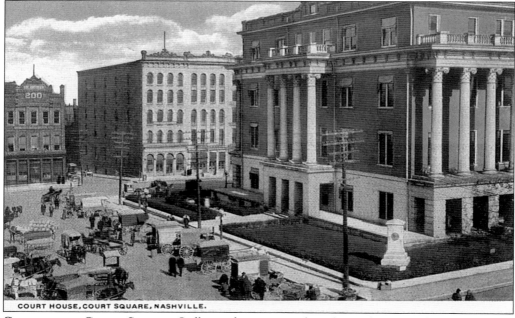

COURT HOUSE, COURT SQUARE, NASHVILLE.

COURTHOUSE, COURT SQUARE. Sadly, nothing pictured in this early postcard remains today. Gone are the Davidson County Court House and all of the buildings pictured to the left.

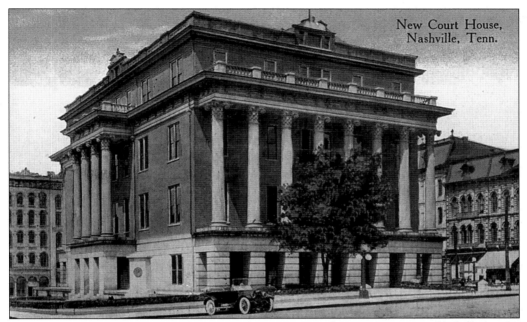

New Court House,
Nashville, Tenn.

NEW COURTHOUSE. This close-up view of the "New Courthouse," as it was called, shows the magnificence of this great Greek Revival building constructed in 1857 at a cost of $420,000. It was the fourth courthouse to occupy this site. The third story contained a public hall in which the 1870 Tennessee Constitutional Convention was held. The buildings to the right of the picture are also gone.

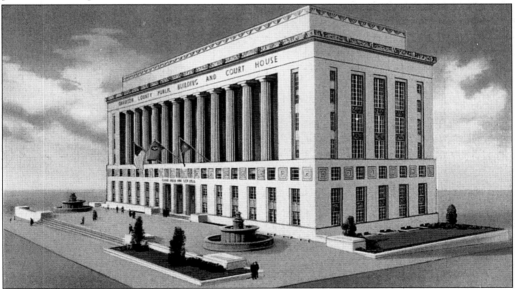

DAVIDSON COUNTY PUBLIC BUILDING. The newer eight-story Davidson County Courthouse and Public Building was built in 1937 at a cost of $2 million. It is the fifth courthouse to occupy the site and at one time contained the county's health department. Through the 1950s, kids often went to the courthouse for shots. Today, the Davidson County Courthouse is reminiscent of a movie set with its magnificent Art Deco decor and padded leather courtroom doors.

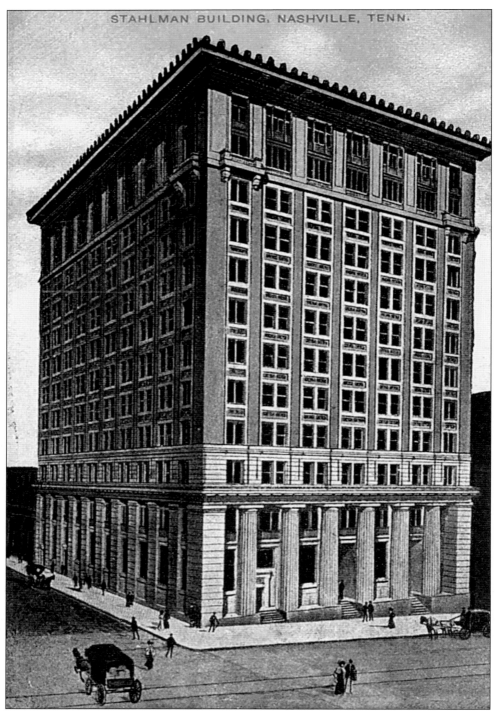

STAHLMAN BUILDING. The Stahlman Building, formerly known as the Fourth National Bank Building, was built in 1905, and is one of several remaining downtown office buildings. It is located across from Public Square at the top of the hill at Third and Union.

Three

DESTINATION NASHVILLE
TRANSPORTATION AND ACCOMMODATION

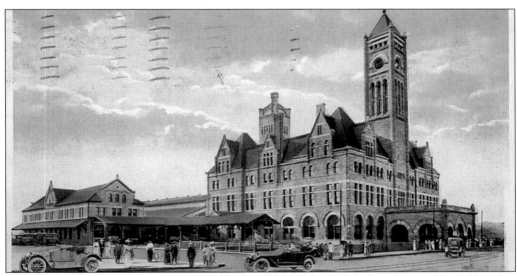

UNION STATION. Union Station was built in 1900 during the heyday of American railroad at a cost of $1 million. It served as the terminal for the Louisville & Nashville and the Nashville, Chattanooga & St. Louis Railways. This 1918 postcard shows the station much as it looks today. It is constructed of cut stone, with an elaborate stained-glass canopy arching high above the great lobby. An open second-story gallery lines the interior walls of the main room. For years the abandoned station remained a home for pigeons and the source of debate among politicians. It probably would have been razed except for the enormous expense involved. For over a decade now, Union Station has, like its contemporary in Chattanooga, served as a first-class hotel.

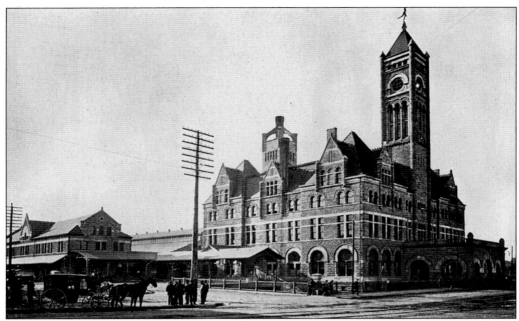

UNION STATION. This earlier photo of Union Station from the same angle shows the 15-foot statue of the formerly esteemed god, Mercury, perched high at the top of the clock tower. The original was sent crashing to the ground during a windstorm many years ago, but has since been replaced with a shorter flat version, which lacks the size and character of the original three-dimensional figure. The glass in the clock tower was blown out during the Tennessee Tornado of 1998.

BUS STATION. Nashville had two main bus stations that survived until the early 1970s. This one, which became the Greyhound station, was located at Fifth and Commerce next door to the Ryman Auditorium (Grand Ole Opry House). Today it serves as a parking lot, and the newer station is located on Eighth Avenue South.

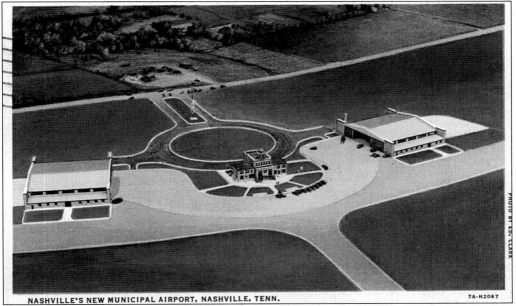

NASHVILLE'S NEW MUNICIPAL AIRPORT, NASHVILLE, TENN. 7A-H2067

AIRPORT. Nashville's first Municipal Airport, known as Berry Field, was built in 1937 on 700 acres of farmland located about 7 miles from town, at a cost of $2.5 million. It was named in honor of state WPA administrator Harry Berry, and was considered to be "one of the most outstanding airports in the United States." You will note not one, but two modern aircraft hangars.

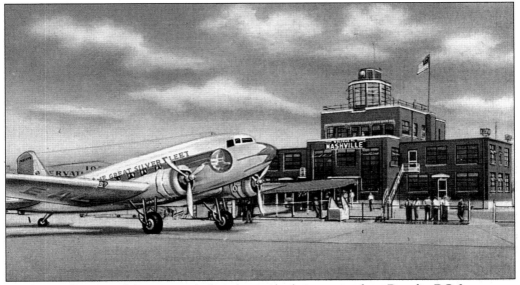

PLANE. At the time of this postcard, this plane, which appears to be a Douglas DC-3, was part of "The Great Silver Fleet." The first Nashville Municipal Airport appears on the right. When this modern facility was constructed, nobody could have anticipated that Nashville would need a larger one before the end of the century. Berry Field was eventually given to the Air National Guard, and there have been two newer municipal airports since, including Nashville International Airport.

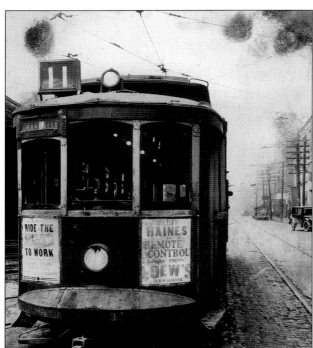

TROLLEY. This photo of a Nashville electric trolley is typical of the many streetcars that used to carry passengers around Nashville and outlying areas. Note the poster on the front touting "Remote Control."

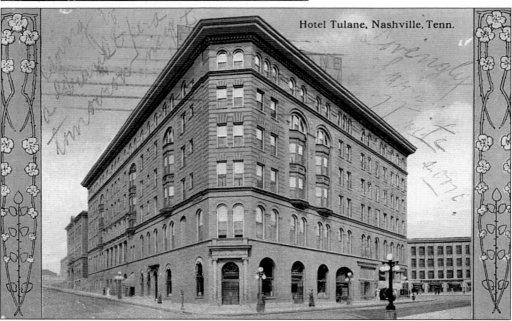

Hotel Tulane, Nashville, Tenn.

TULANE HOTEL. This 1912 postcard shows the late Tulane Hotel, which was located at the intersection of Eighth Avenue North and Church Street. What is especially significant about this hotel, in terms of Nashville's history, is that it was the site of Castle Studio, Nashville's first recording facility. As Nashville's first studio in the days before record companies had their own studios, it had a lock on all of Nashville's recordings until famed producer Owen Bradley opened his own studio, Bradley's Barn, in 1953.

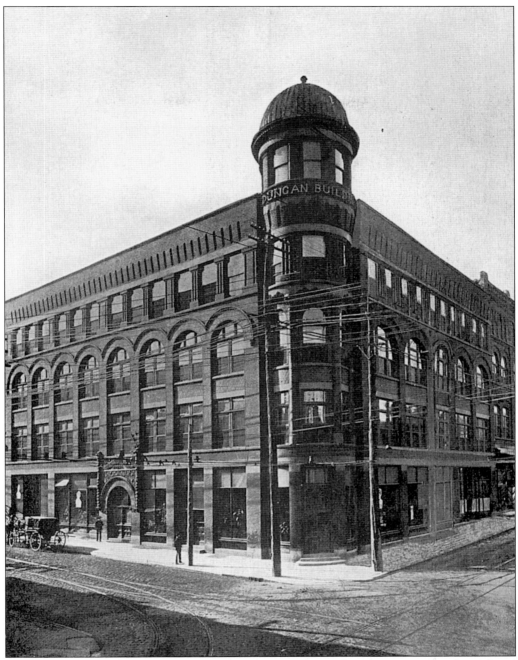

DUNCAN HOTEL. Today, little evidence remains to indicate that this once magnificent hotel ever existed. It was located downtown at the corner of Cedar and Cherry Streets.

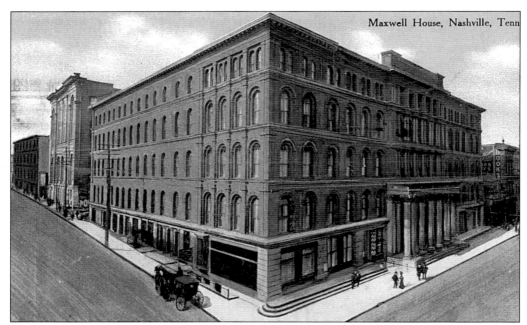

MAXWELL HOUSE HOTEL. "Maxwell House, good to the last drop." That famous saying was attributed to President Roosevelt after a cup of the legendary coffee at Nashville's famous Maxwell House Hotel. Actually, the history of the Maxwell House begins long before that casual remark made the coffee known worldwide. Construction of the hotel at Fourth Avenue North and Church Street began in 1859, but the war broke out before the hotel was finished. It served as a Confederate barracks, then passed to Union hands as a prison. The hotel was completed after the war, and opened in September 1869, quickly becoming one of the South's grand hotels. By the 1950s, its glory had faded, and the once proud structure was destroyed by fire on Christmas Night, 1961.

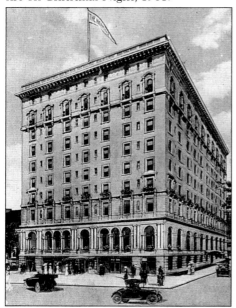

HERMITAGE HOTEL. The nine-story, 250-room Hermitage Hotel, built in 1910, is Nashville's only remaining grand hotel. It is similar to the Peabody Hotel in Memphis and Chattanooga's Read House, but smaller than both. Today, the hotel is operated under the Westin Hotel banner, and is the only surviving building from its period that is located in the area now known as Legislative Plaza. Minnesota Fats, probably the most famous pool player of all time, maintained a permanent suite here during the last years of his life.

ANDREW JACKSON HOTEL. The 400-room Andrew Jackson Hotel was located at the corner of Deaderick Street and Sixth Avenue, across from the War Memorial Building and in sight of the State Capitol Building. It was razed to make way for some more government buildings, and its destruction heralded the ruination of the rest of Deaderick Street, formerly the "coolest" downtown street in the city. This fanciful artist's rendering shows what looks like a 1939 Lincoln Zephyr convertible flying through the summer night with its top down.

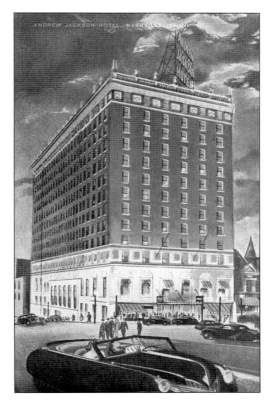

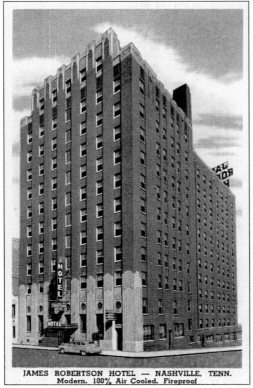

JAMES ROBERTSON HOTEL — NASHVILLE, TENN.
Modern. 100% Air Cooled. Fireproof

JAMES ROBERTSON HOTEL. The James Robertson is still standing on Seventh Avenue North, but no longer as a hotel. It is now called the James Robertson Apartments. The back of this postcard advertises the hotel as a "Commercial Uptown Hotel with 250 rooms, and 25 parlor suites with kitchenettes. It is alleged to be modern, fireproof, 100% air cooled, and possessed of a basement garage."

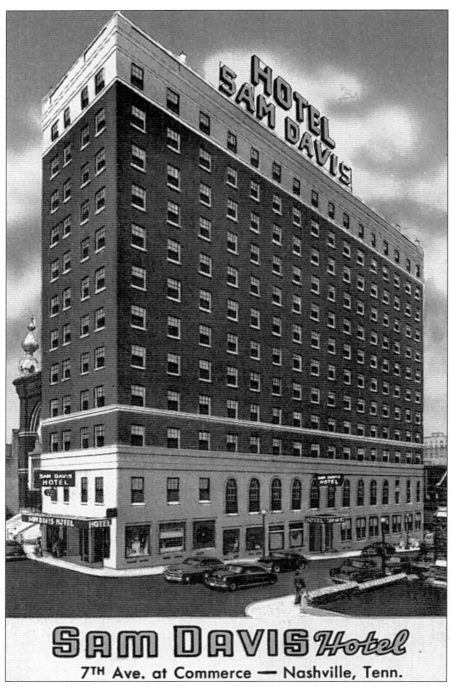

Sam DAVIS Hotel
7TH Ave. at Commerce — Nashville, Tenn.

Sam Davis Hotel. Long known as "the Sam D" by locals, the Sam Davis Hotel boasted 250 outside rooms, all with combination tub and shower baths and circulating ice water. Many had televisions. All of the rooms probably faced outside because the lot was supposedly only 40 feet wide. The Sam Davis Hotel met the wrecking ball in 1984 to make way for what is now called the Renaissance Hotel.

NOEL HOTEL. The Noel Hotel is still standing proudly at the corner of Fourth and Church across the street from where the Maxwell House Hotel once stood. Today, however, the old hotel serves as an office building. In its prime, the Noel was one of Nashville's premier hotels, and offered 24-hour room service, as well as radio and television. Famed Printer's Alley is located behind the hotel building.

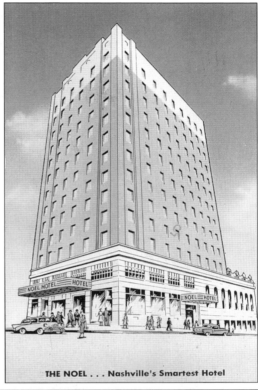

THE NOEL . . . Nashville's Smartest Hotel

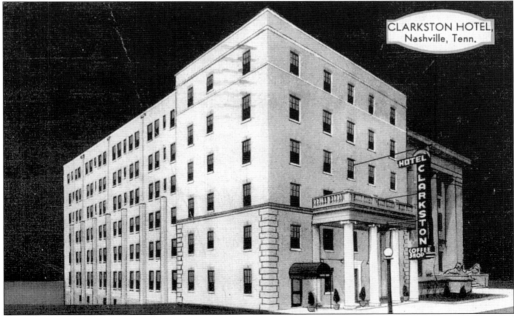

CLARKSTON HOTEL, Nashville, Tenn.

CLARKSTON HOTEL. This 1946 postcard shows the Clarkston Hotel in its prime. Located downtown across from Memorial Square, it claimed to be fireproof and possessed such amenities as a coffee shop and parking facilities.

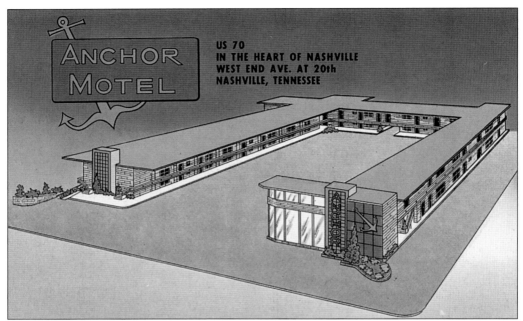

ANCHOR MOTEL. This artist's depiction of the 67-room Anchor Motel probably preceded actual construction of what was billed as "Nashville's Only Downtown Motel." The all-new modern motel offered Beautyrest Mattresses, tile baths with glass shower doors, carpeting, free TV, and a telephone in each room.

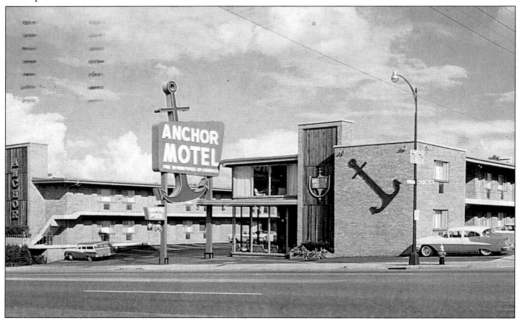

ANCHOR MOTEL. This is a postcard photo of the Anchor Motel. Due to the Anchor Motel's convenient location at Twentieth and West End, as well as inexpensive rates, it was a favorite with country music artists throughout its life. By the end of the 1970s, it was all over for the Anchor. Today, a Hampton Inn occupies the site.

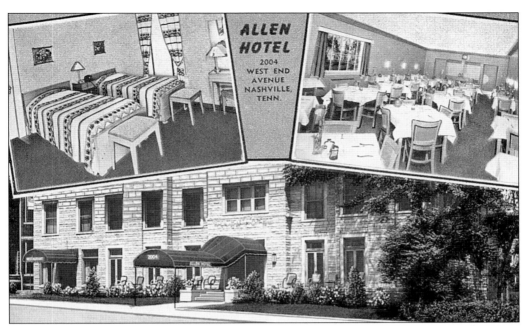

ALLEN HOTEL. The Allen Hotel was a popular feature of the landscape along West End Avenue until its destruction. It was known by the locals for its excellent restaurant. This postcard depicts the restaurant's comfortable interior, as well as room furnishings in step with the times.

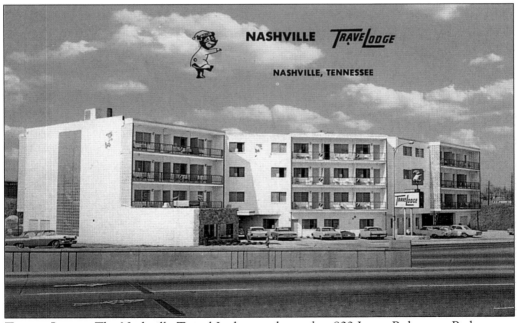

TRAVEL LODGE. The Nashville Travel Lodge was located at 800 James Robertson Parkway on the north side of the base of the Tennessee State Capitol Building. During the early 1950s, the area was cleared of decaying mansions and other worthwhile structures as part of an "urban renewal" project. Today, all that remains of this former Travel Lodge are memories.

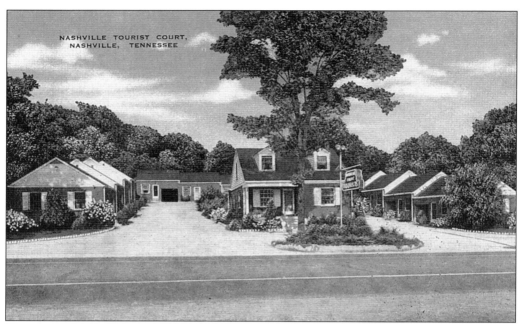

NASHVILLE TOURIST COURT. The Nashville Tourist Court was located at 2526 Franklin Road on the southern edge of town in the Melrose area. It consisted of 19 free-standing one- and two-room brick cottages. Some of the individual cottages still remain, but have been rented to various small businesses and individuals.

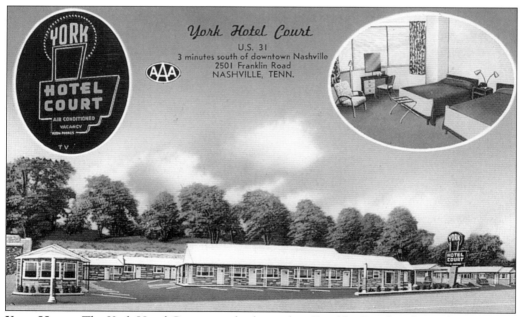

YORK HOTEL. The York Hotel Court was also located on Franklin Road in the Melrose area. In fact, it was just down the road from the motel depicted in the previous card. This area was close to town, and at the time, in a good neighborhood. These tourist courts are indicative of the trend away from downtown hotels. Note the Spartan interior appointments.

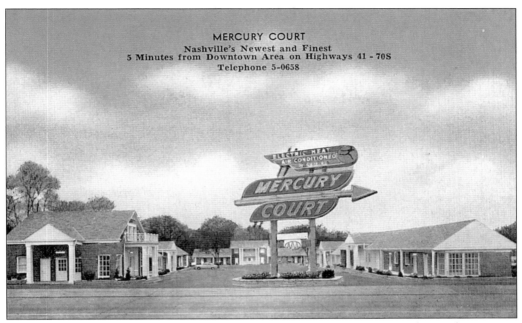

MERCURY COURT

Nashville's Newest and Finest
5 Minutes from Downtown Area on Highways 41 - 70S
Telephone 5-0658

MERCURY COURT. The Mercury Court was located on Highway 41-70 South, another area on the outskirts of town that was a popular location for tourist courts and motels.

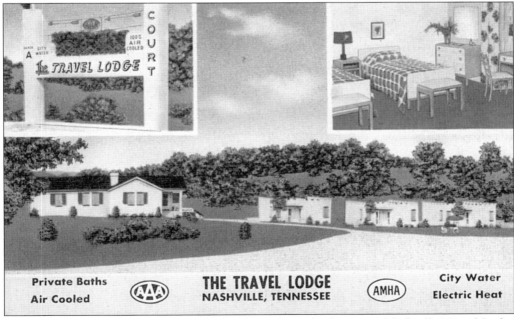

Private Baths — Air Cooled — THE TRAVEL LODGE NASHVILLE, TENNESSEE — City Water — Electric Heat

TRAVEL LODGE. This Travel Lodge obviously predates the four-story Nashville Travel Lodge formerly located at the base of the State Capitol Building. These individual masonry cottages were situated on a pastoral setting 9 miles from downtown. The single, double, twin, and family rooms were equipped with Simmons Metal Furniture.

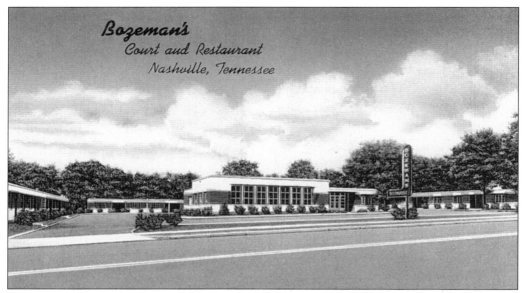

BOZEMAN'S. Recommended by both AAA and Duncan Hines, Bozeman's was also located near Nashville on US 41-70 South. Like many of the motel courts of the time, it advertised electric heat, tile bathrooms, air conditioning, and showers. Bozeman's was renown throughout Nashville for its famous steaks. One giant steak on the menu was advertised as free to the person who could eat the entire steak.

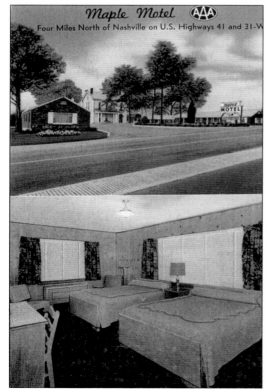

MAPLE MOTEL. The Maple Motel was located 4 miles north of Nashville on U.S. 41 and 31 West. The double beds and pine-paneled walls were common interior appointments during the era of the tourist courts.

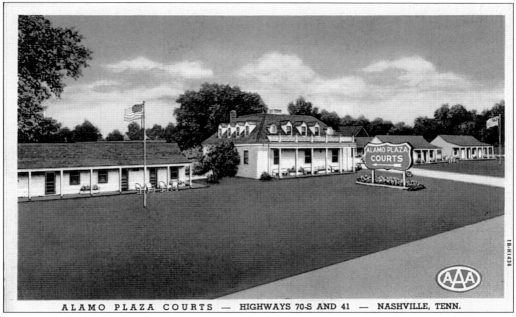

ALAMO PLAZA COURTS — HIGHWAYS 70-S AND 41 — NASHVILLE, TENN.

ALAMO PLAZA COURTS. The Alamo Plaza Courts, now just a memory, were also located on 41-70 South.

LEE'S MOTEL AND RESTAURANT. Lee's Motel and Restaurant consisted of 14 modern (at the time) stone cottages, offering amenities such as private baths and showers, innerspring mattresses, air conditioning, and electric heat. Free-standing cottages offered privacy and architectural interest to travelers of the motel court era.

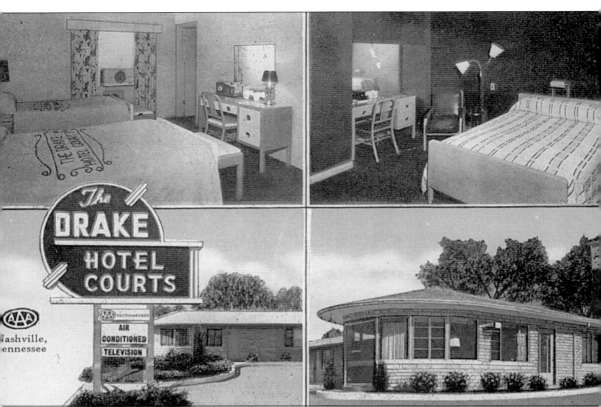

THE DRAKE HOTEL COURTS. The Drake Hotel Courts was opened in 1950 by Paul Budslick, and is probably Nashville's last high-quality operational tourist court. Today, it looks much as it did in this 1954 postcard, which shows interior accommodations as well as a glimpse of the building. Not long ago, the Drake was featured in the River Phoenix and Sandra Bullock movie, *A Thing Called Love*. Today, the Drake has one of Nashville's best outdoor neon signs.

Four

BUILDINGS

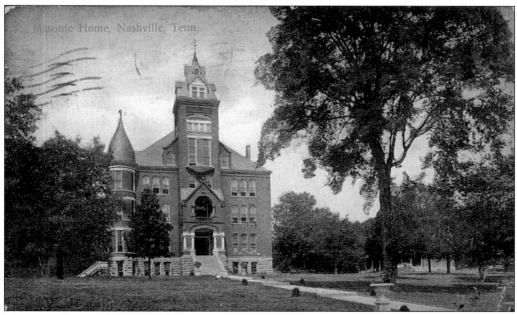

MASONIC HOME. This 1909 photo of the Masonic Home for Widows and Orphans shows the completed structure, which opened in 1892 on Gallatin Road in the area known today as East Nashville. Jere Baxter donated the 10-acre tract of land upon which it was built.

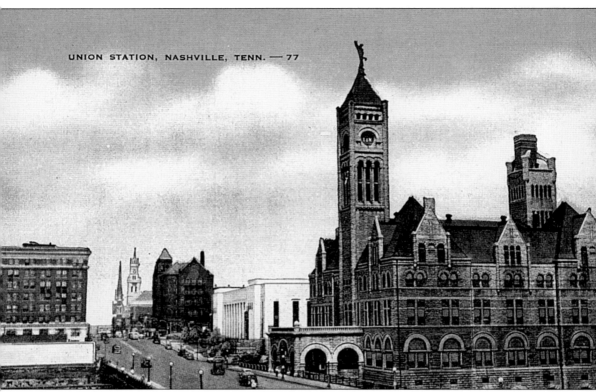

UNION STATION. This view of Union Station from the west shows the former office building of the Nashville, Chattanooga & St. Louis Railroad. This building was destroyed to make way for a hotel. The dark building in the center of the picture was also razed in the 1950s and replaced by the Federal Courthouse Building.

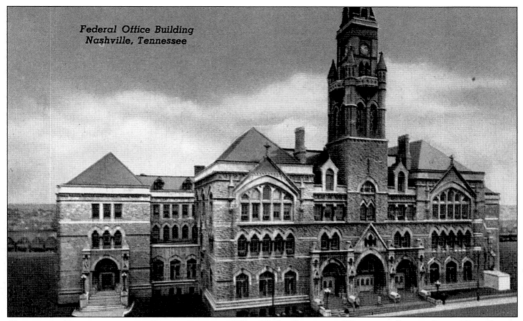

Federal Office Building
Nashville, Tennessee

CUSTOMS BUILDING AND POST OFFICE. The U.S. Customs House is located on Broadway, directly across the street from Hume-Fogg High School. This massive, heavy-looking stone building served as Nashville's main post office until the newer Art Deco post office building was constructed next door to Union Station in 1934. This is now a federal office building.

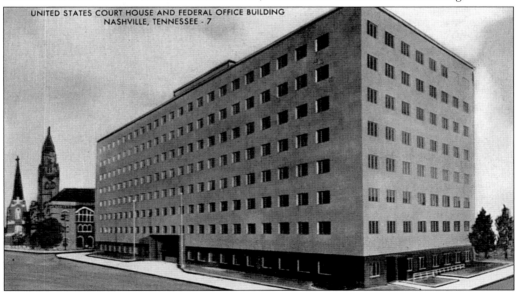

UNITED STATES COURT HOUSE AND FEDERAL OFFICE BUILDING
NASHVILLE, TENNESSEE - 7

FEDERAL OFFICE BUILDING. This new eight-story, 310,000-square-foot Federal Building and Court House was erected in 1951 at a cost of $5 million. Teamsters leader Jimmy Hoffa was tried in this building prior to his unfortunate disappearance. Visible to the left side of this postcard is the building described above. To the far left is the church tower of the First Baptist Church. The beautiful church building was destroyed and replaced with a more modern church building, but the steeple pictured here is still standing.

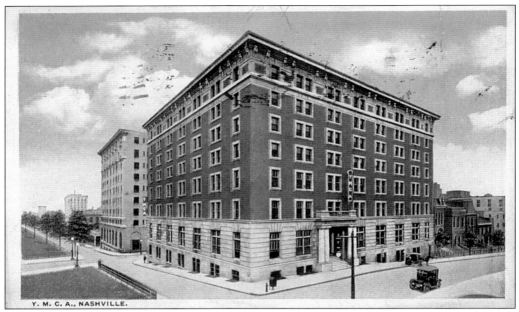

Y. M. C. A., NASHVILLE.

YMCA. This 1918 postcard shows the former downtown YMCA building, located at the corner of Seventh and Union Streets. In 1912, the fireproof, eight-story building was completed on a 142-by-139-foot parcel of land across the street from what is now Legislative Plaza. The white building immediately to the left of the YMCA is the Hermitage Hotel. During its life, the YMCA served as a home away from home for 270 young men. It offered a large indoor pool, a gym, and basketball courts. The building was razed in the late 1960s and was replaced by Nashville's first Hyatt Regency Hotel. That hotel is now the Holiday Inn Crowne Plaza.

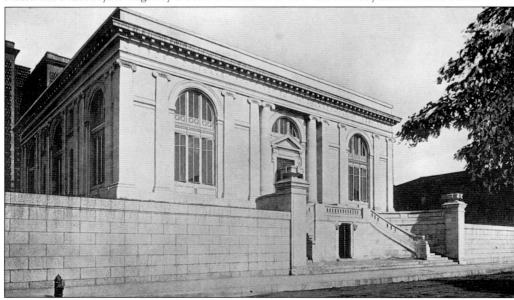

CARNEGIE LIBRARY. Old Carnegie Library was erected downtown in 1914, near the area now known as Legislative Plaza. The nameplate, cornerstone, and some other architectural remains rest on a small patch of ground outside Nashville's current Main Public Library.

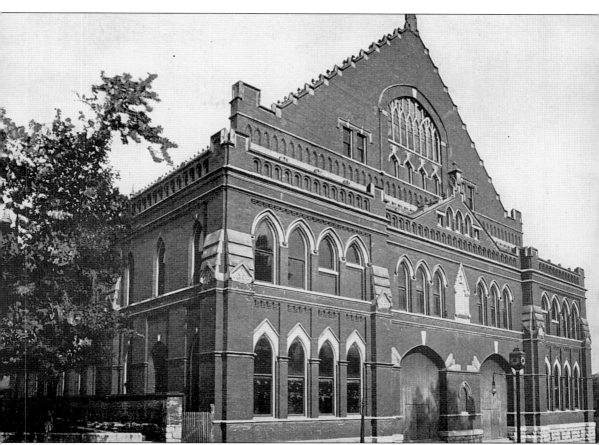

Ryman Auditorium. Although it was not the first home of the Grand Ole Opry, the Ryman Auditorium is known to most people as "The Opry House." The auditorium opened in 1892 as the Union Gospel Tabernacle and hosted sermons by the most famous evangelists of the day, including Billy Sunday and Norman Vincent Peale. Later, a balcony was added from money donated by the Confederate Veterans. In 1901, a stage was added for performances by the Metropolitan Opera. For years, the Ryman served as what might best be called Nashville's first civic center, hosting performances by some of the most famous performers in the world, including Isadora Duncan, Will Rogers, Mae West, Katherine Hepburn, Basil Rathbone, Orson Welles, Bela Lugosi, and Charlie Chaplin. Today, the Ryman has been restored and hosts top name concerts.

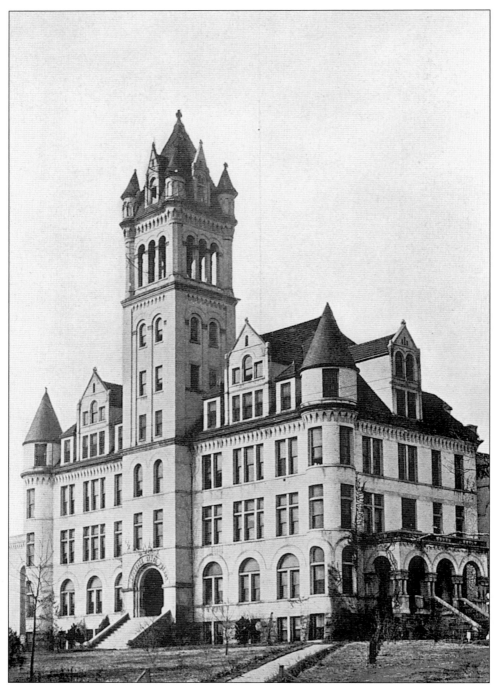

TENNESSEE STATE PRISON. The Tennessee State Prison, which was built in 1897 and resembles some sort of surreal, nightmarish castle, still stands at its original location on Centennial Boulevard about 10 miles from town. It was the scene of many state executions conducted with Tennessee's electric chair, known jokingly as "Old Sparky." Though the prison has been abandoned, it is well guarded, and the public is not permitted to enter.

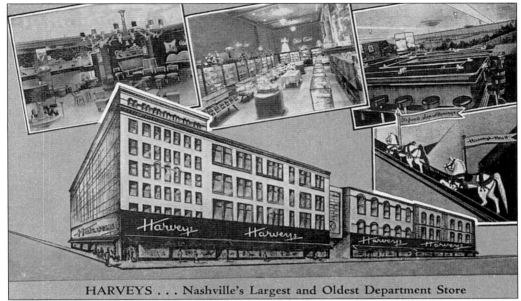

HARVEYS . . . Nashville's Largest and Oldest Department Store

HARVEY'S. Harvey's Department Store ruled the retail roost in the days when all department stores were located downtown. As Nashville's oldest and largest store, Harvey's was noted for its unique and authentic hand-carved, wooden carousel horses. These brightly colored horses were placed near escalators throughout the store. Harvey's had caged live monkeys, a giant wooden cigar store Indian, restaurants, a confectionary, and clothes and dry goods of all types. With the movement of shopping from downtown to the outlying suburban areas, downtown Nashville died as a shopping area, and Harvey's, sadly, went with it.

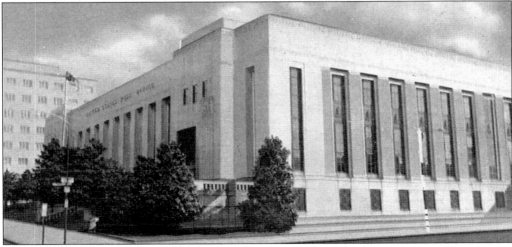

NEW POST OFFICE. Strangely, this postcard lists this building as "The New Post Office." This is peculiar in that this marble and granite building was completed in 1934, while the Federal Building, pictured to the left, was built later in 1951. For a time, the new Nashville Post Office was the city's main post office. It is still in operation as a post office, although there are plans to convert it into an art museum. It is one of the few remaining Art Deco-styled buildings in Nashville. Its unusually simple but elegant interior contains large elaborate aluminum decorations depicting industry, agriculture, commerce, and transportation in Tennessee.

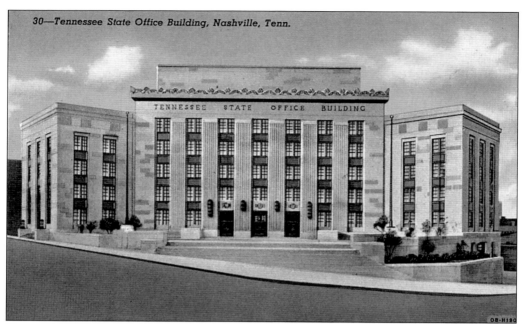

30—*Tennessee State Office Building, Nashville, Tenn.*

TENNESSEE STATE OFFICE BUILDING. This public building was constructed between 1937 and 1940 on a site next to the State Capitol grounds. Architecturally, it represents the zenith of Art Deco design, but also possesses classic Greek and Roman elements.

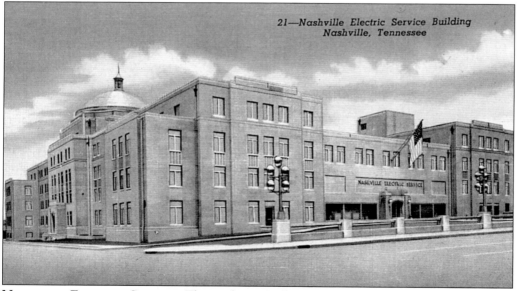

21—*Nashville Electric Service Building*
Nashville, Tennessee

NASHVILLE ELECTRIC SERVICE. The architecturally interesting and impressive Nashville Electric Service Building was completed in 1952 for $2.5 million, and is located on Church Street very close to the heart of the city. A large dome containing a revolving multi-colored beacon searchlight sits atop the building. This colorful light was turned on every night for years, along with floodlights that illuminated the outside of the building. During the energy crisis, the beacon's continued use was considered hard to justify, as all utilities nationwide saw rate hikes and awareness of energy use increased.

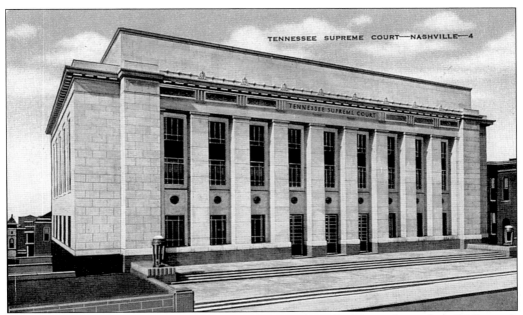

TENNESSEE SUPREME COURT. The Tennessee Supreme Court Building is located at 401 Seventh Avenue North, at the western base of the State Capitol Building, next door to the state archives. The Greek-inspired structure was built entirely of Tennessee marble at a cost of $750,000, and dedicated on December 4, 1937.

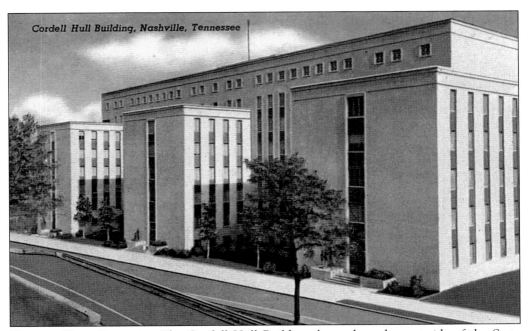

CORDELL HULL BUILDING. The Cordell Hull Building, located on the east side of the State Capitol just beyond the outside edge of the grounds, is another excellent example of wonderful architecture as applied to public buildings.

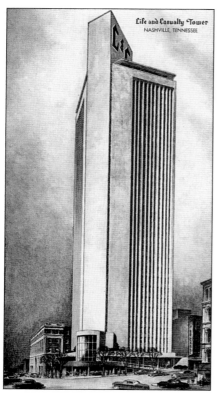

L & C TOWER. Architecturally, the Life and Casualty Insurance Building ushered Nashville into the modern age. As the city's first skyscraper, the 30-story L & C Tower was, during its era, the tallest commercial structure in the southeastern United States. The observation deck on the top floor was open to the public, and for a quarter one could stand on the deck and supposedly see for a distance of 26 miles. Although the L & C Tower has been eclipsed by newer and taller buildings since it was built in the 1950s, it has stood the test of time architecturally, and is every bit as elegant now as when it was first constructed. The Maxwell House Hotel is visible to the right of the picture.

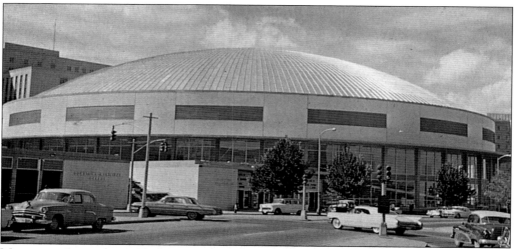

MUNICIPAL AUDITORIUM. Today, many Nashville politicians consider the Municipal Auditorium to be more of a problem than anything else. When it opened in 1964, however, it was one of the most futuristic auditoriums in America. Construction started in 1959, the year that Cadillac had its biggest fins, and "the future" meant space-related architecture. The 10,000-seat Municipal Auditorium, which resembles a flying saucer, has hosted all types of trade events, concerts, and plays—in fact, everything from the Rolling Stones, Led Zepplin, and the Jacksons, to *Jesus Christ Superstar*, Nashville's first Fan Fair, and first CMA Awards Show. It remains a viable and excellent mid-size arena.

Five

THE HERMITAGE

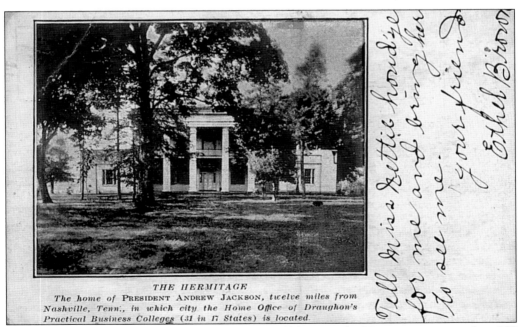

THE HERMITAGE

The home of PRESIDENT ANDREW JACKSON, twelve miles from
Nashville, Tenn., in which city the Home Office of Draughon's
Practical Business Colleges (31 in 17 States) is located.

Tell Miss Lettie howdize for me and bring her to see me. your friend Ethel Brown

FRONT VIEW OF THE HERMITAGE. The site that would become the Hermitage is situated on 500 acres approximately 12 miles from town. Part of its original log cabin still exists. The Greek Revival mansion was built in 1819, enlarged in 1831, and rebuilt after an 1834 fire.

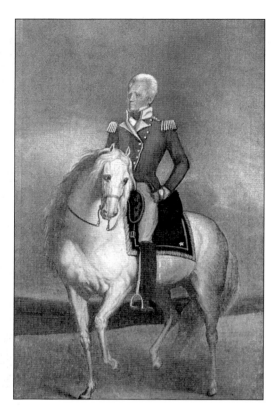

ANDREW JACKSON. Andrew Jackson, the seventh president of the United States, has moved from the actual to the mythological in terms of reputation. Still today, he is adored by admirers and cursed by those who disagreed with his policies. From New Orleans to Nashville, however, he will always be revered as "Old Hickory," the savior of New Orleans, a handsome, rugged individual who had no hesitation whatsoever in settling even the slightest misunderstanding with pistols upon "The Field of Honor." His stately residence, the Hermitage, is one of the finest in the South and contains many of his personal items.

RACHEL DONELSON JACKSON. Rachel Jackson, Andrew Jackson's wife, was controversial in her own right. It was subsequently ascertained that she and Jackson were married before her divorce was final. This unintentional oversight created quite a great scandal in provincial, frontier Nashville. This miniature of Rachel was painted by Anna Peale in Washington, D.C., in 1815, and after her death, was carried by Jackson on his person, and placed on his bedside table at night.

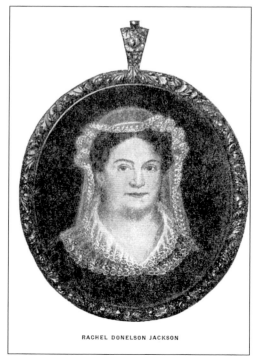

RACHEL DONELSON JACKSON

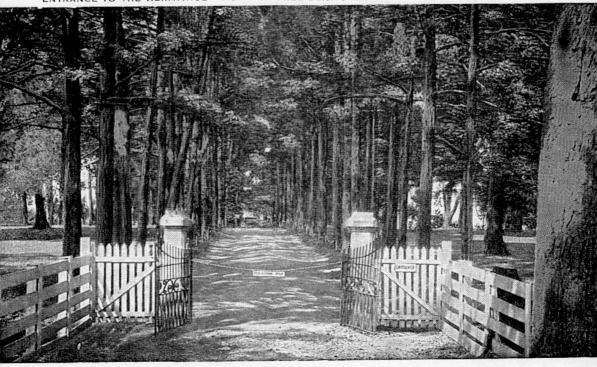

GATES TO THE HERMITAGE. Many of the nearly 200-year-old trees that graced the lawn and grounds of the Hermitage were planted by Jackson himself, and later destroyed by the tornado that so devastatingly struck Nashville in April 1998.

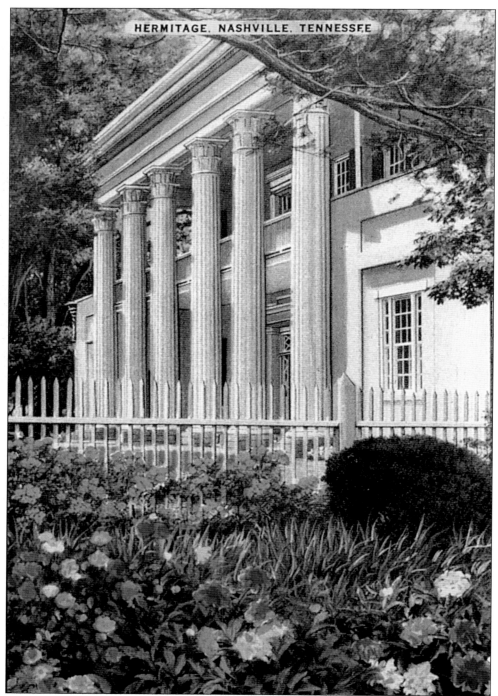

SIDE VIEW OF THE HERMITAGE. This is possibly the most beautiful angle at which to view the Hermitage. The house and 500 acres were purchased by the State of Tennessee for the amount of $48,000 in 1856. The Ladies Hermitage Society was created for its preservation in 1889.

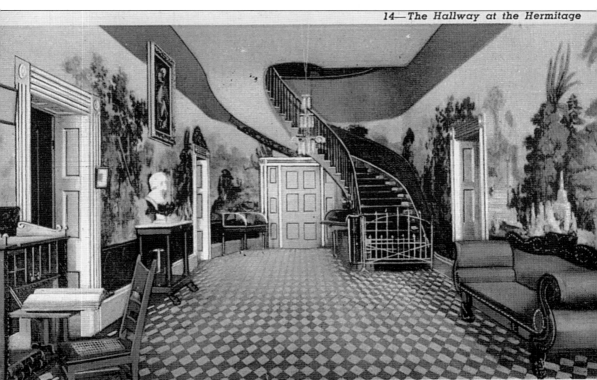

General Andrew Jackson's Home, near Nashville, Tenn.

8A-H1558

THE HERMITAGE HALLWAY. The classic structural design of Greek Revival architecture is reflected in this interior view just inside the front door of the house. The standard H configuration is clearly evident, with a large central hallway and two rooms off either side. Despite the opulence of this particular interior, its configuration is the same as that of any Tennessee frontier cabin. In poorer circumstances and in earlier houses, the hallway would be open from front to back, all the way through the house. Eventually doors were added at each end, the horses were moved to barns, and a second story would be added if more space was required.

57

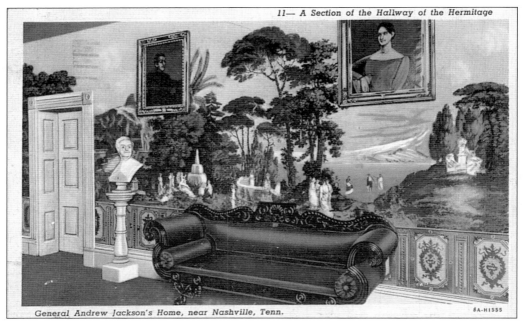

General Andrew Jackson's Home, near Nashville, Tenn.

8A-H1555

SECTION OF HALLWAY. This section of the hallway shows a Federal-styled sofa, a marble bust of Andrew Jackson, and hand-painted wallpaper of the style typically found in expensive homes of the period.

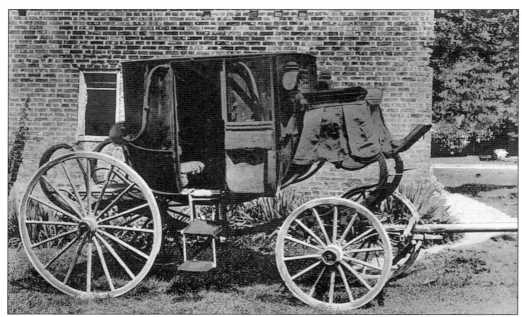

STAGECOACH. This formal brougham, pictured here in front of the smokehouse on the Hermitage property, was the preferred transportation of Andrew Jackson. When one considers how slow and dangerous travel was in Jackson's day, it must be said that he really got around. He was well known from Washington, D.C., to Nashville, New Orleans, and Florida.

58

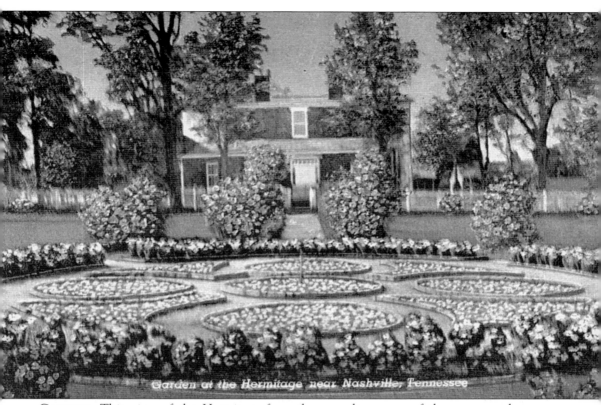

Garden at the Hermitage near Nashville, Tennessee

GARDENS. This view of the Hermitage from the rear shows one of the many gardens on the grounds.

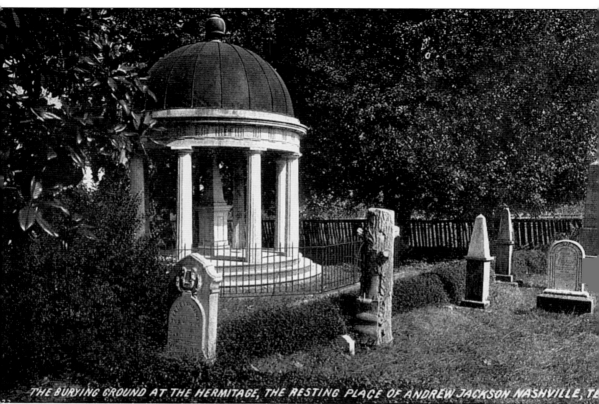

THE BURYING GROUND AT THE HERMITAGE, THE RESTING PLACE OF ANDREW JACKSON NASHVILLE, T

TOMB. Andrew Jackson and his wife, Rachel, are buried on the grounds of the Hermitage. The burial of the owners and other relatives within a family graveyard or mausoleum on the plantation property was a common practice in the South prior to the War Between the States.

Six

SOCIAL CLUBS, PARKS, AND RECREATION

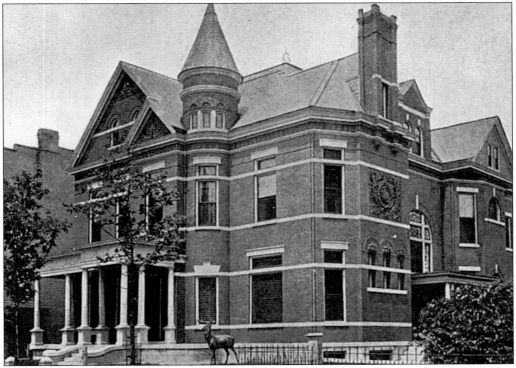

ELK'S CLUB. The Elk's Club Lodge House pictured here was originally one of downtown Nashville's many mansions. In the early days of the city, the majority of citizens literally lived downtown. This house was located diagonally across the street from the Hermitage Hotel, and directly across from Memorial Square (Legislative Plaza). It survived the wrecking ball through the 1960s.

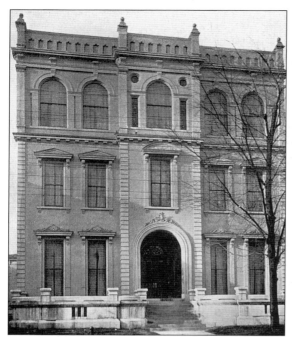

HERMITAGE CLUB. The Hermitage Club was originally an elegant three-story private residence located next to the Hermitage Hotel. During the War Between the States, it served as Federal headquarters for several different generals, including Rosecrans, Sherman, Thomas, and Grant. In fact, Grant was using this house as headquarters when he was appointed lieutenant general and commander and chief of the United States Armies. In its incarnation as the Hermitage Club, this house served as Nashville's premier business club.

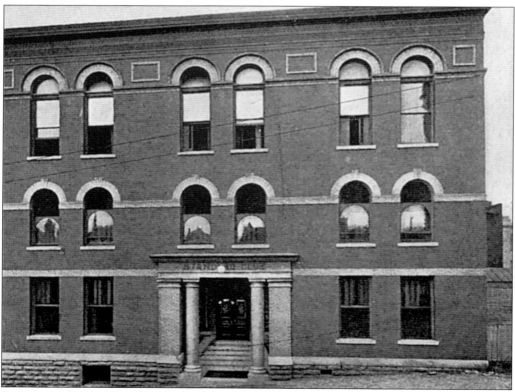

STANDARD CLUB. The Standard Club was founded in October 1882, evolving from the Condordia Club. It was Nashville's premier Jewish Club at the time.

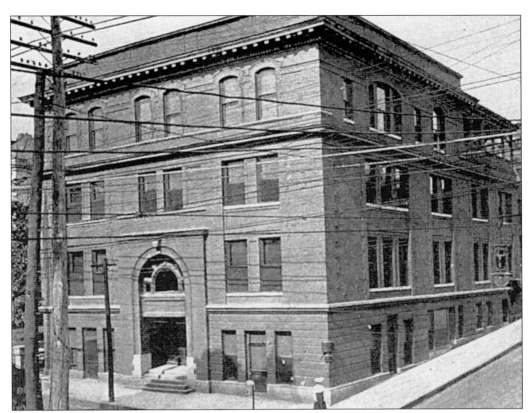

UNIVERSITY CLUB. The University Club, as seen in this 1900-era photograph, was originally a downtown social club for college graduates of all schools.

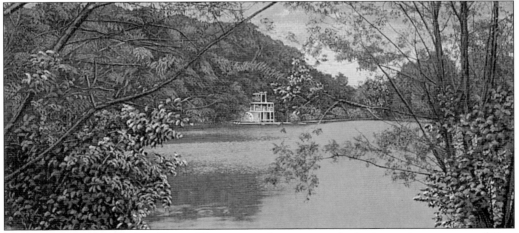

BOAT LANDING AT SHELBY PARK. These next three postcards depict various aspects of East Nashville's Shelby Park. Pictured here is the boathouse on Lake Sevier. In the early days of the city, this was the prime residential area of choice. The area is located across the Cumberland River and, at one time, contained many of Nashville's finest homes and best architecture. A freak 1916 fire aggravated by unusually strong winds destroyed 64 acres of prime residential property in five hours, leaving nearly 3,000 people homeless and 700 buildings in ruins.

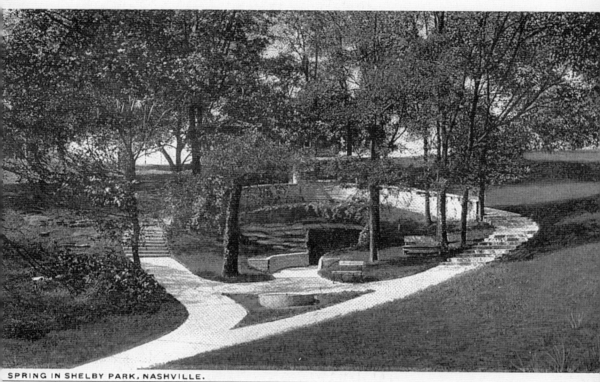

SPRING IN SHELBY PARK, NASHVILLE.

SPRING IN SHELBY PARK. While only a few of the remarkable mansions, churches, and other buildings remain in East Nashville, Shelby Park can still be found much as it was during the early 1900s. It consists of several hundred wooded acres, a large lake, winding driveways, and walking paths.

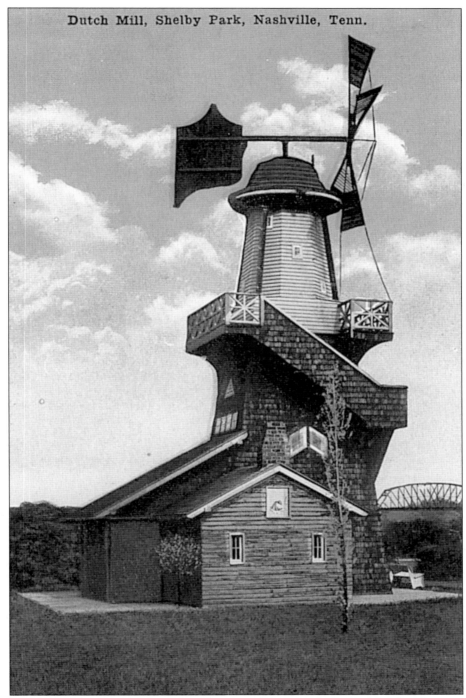

Dutch Mill, Shelby Park, Nashville, Tenn.

Dutch Mill. This very unusual Dutch Mill was a well-known Shelby Park landmark, completed prior to the park's opening in 1912. Unfortunately, the windmill burned in the 1940s. As interesting and unique as this was, it seems unlikely that anyone would think to construct something similar in any Nashville park today.

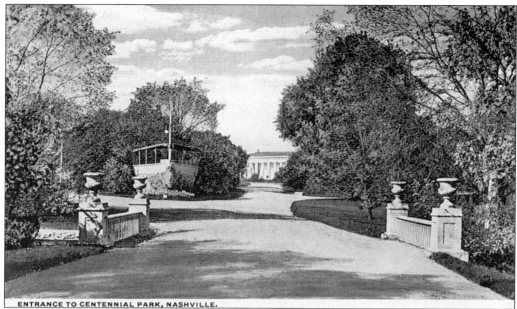

ENTRANCE TO CENTENNIAL PARK, NASHVILLE.

ENTRANCE TO CENTENNIAL PARK. Centennial Park hosted the Tennessee Centennial Exposition in 1897 in honor of the state's 100th anniversary. Surviving photographs show incredible buildings, a giant seesaw, and other magnificent exhibits that are mostly gone now. Pictured here to the left is a replica of the bow of the former battleship *Tennessee*. The large dreadnoughts of the 1890s were as ornamental and beautiful as they were ponderous. This large cement recreation of the ship's prow is affixed with the actual bronze embellishments from the former battleship.

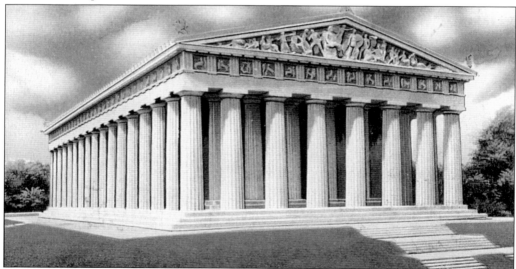

THE PARTHENON. This exact scale replica of the famous Greek building in Athens was constructed for the Centennial Exposition, but like the other fabulous buildings from that event, it was erected as a temporary structure. Due to its extreme popularity, the replica was rebuilt into a permanent structure between the years of 1925 and 1931. Today, the Parthenon houses an art museum, and is currently undergoing extensive exterior restoration.

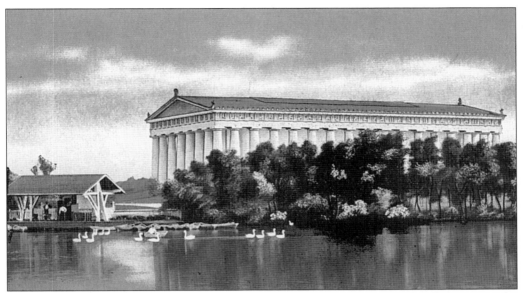

THE PARTHENON AND LAKE WATAUGA. The Parthenon is an impressive site from any angle, but especially in this case, as seen from across Lake Watauga, which was named in honor of the area's first settlers. Centennial Park is without doubt Nashville's most widely used park. Located in the western part of downtown, the park is convenient to the universities, as well as Music Row. It is the site of many public activities, including concerts, rallies, arts and crafts shows, and is an excellent place to spend lunch hour.

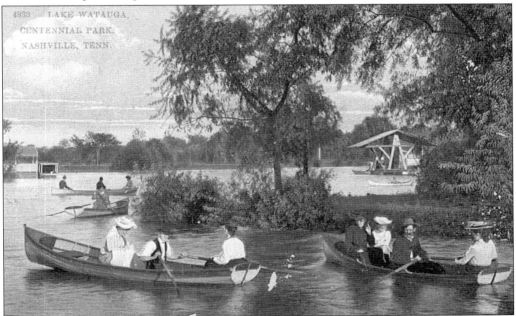

LAKE WATAUGA. This very early postcard photo, probably taken prior to 1915, shows what appears to be a lake crowded with boats. Today, pedal boats are available for public rental, and fishing is permitted as well. At one time, there was a public swimming pool, but that is long gone. Centennial Park was heavily damaged and lost many trees during the tornado of 1998.

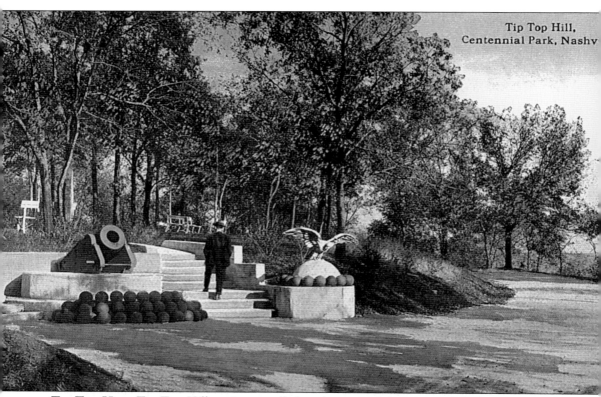

TIP TOP HILL. Tip Top Hill, as it was called at the time of this postcard, looks pretty much the same now as it did then (probably around 1915). The large bore cannon depicted is a Civil War-era mortar, and was used for what was then considered to be long distance bombardment.

ENTRANCE TO WARNER PARK. This is the main entrance to the 2,055-acre Percy Warner Park, the larger of the two Warner Parks. These orchard rock gates are located at the end of Belle Meade Boulevard in Nashville's most desirable residential area. The park entrance is little changed today except for the presence of fairly large cedar trees just through the gates on both the left and right sides. The grassy median in the center foreground is now lined with trees, but at one time contained steel rails for the trolleys that serviced this area.

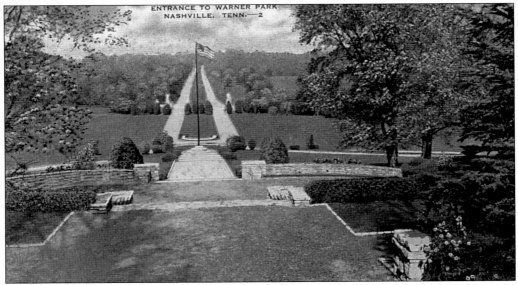

ENTRANCE, VIEW FROM INSIDE THE PARK. This view shows the entrance pictured from the opposite side as seen in the preceding card. From within the park, the entrance is viewed from a position partially up the hill. What is obvious in this depiction is the complete absence of all houses. Today, there are fine houses visible as far as the eye can see. Within this section of the park, a paved 5.7-mile loop, as well as horse and walking trails, provide a refreshing natural beauty year round.

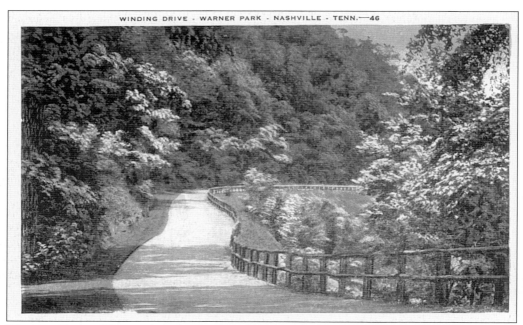

WINDING DRIVE. The winding drive pictured here is a favorite area for cyclists and pedestrians, as well as cars. In addition to Percy Warner Park, there is a smaller, 607-acre park known as Edwin Warner Park, which is part of the Warner Park area.

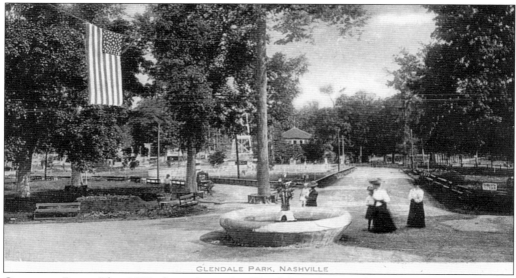

GLENDALE PARK, NASHVILLE

GLENDALE PARK. This 1900 photo shows the Glendale Park in Nashville. The park was owned by the Nashville Railway and Light Company, and was located at the end of the railway route on a 64-acre tract in the Leland Lane Glendale area. It opened in 1888 with steam-powered trains, and switched later to electric streetcars. A zoo was added in 1912, and the place was generally known from that point forward as the Glendale Zoo.

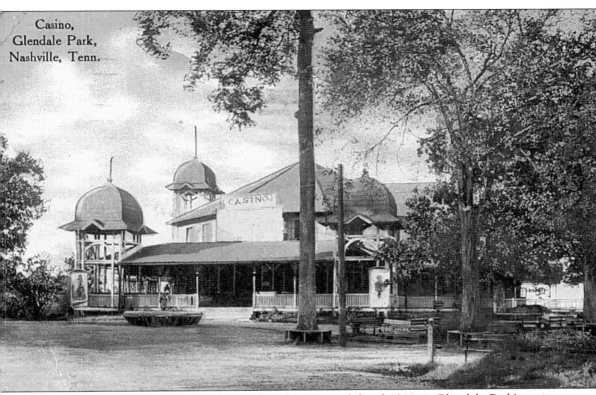

Casino,
Glendale Park,
Nashville, Tenn.

CASINO. This large building, as depicted in this postcard dated 1911, is Glendale Park's main building. This postcard was written in French, postmarked in Nashville, and mailed to Paris, France. One cannot help but wonder how it ever made its way back to Nashville. The park closed in 1932, most likely a casualty of both the Great Depression and a diminished need for streetcars.

Tennessee State Fair Grounds, Nashville, Tenn.

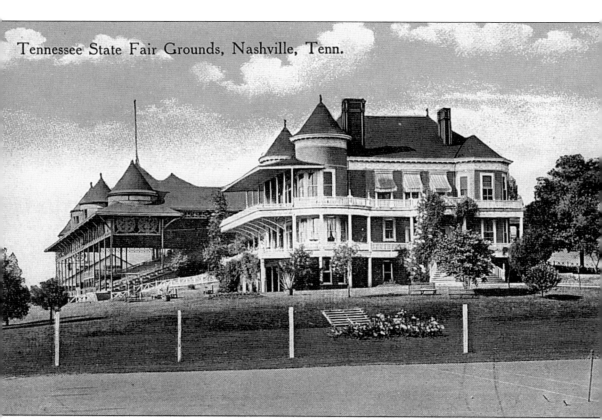

TENNESSEE STATE FAIRGROUNDS. The beautiful Victorian-era Tennessee State Fairgrounds burned to the ground on the night of September 20, 1965. The structure to the left side of this picture shows the grandstand, which was very much reminiscent of Louisville's famous Churchill Downs. Horse and harness racing were frequent events at the fairgrounds during the early part of the twentieth century. Since the fire started while the annual State Fair was in progress, crowds slowed firefighters' response time, and strong winds spread the fire. When it was over, all of the old wooden buildings were destroyed.

Seven

CHURCHES

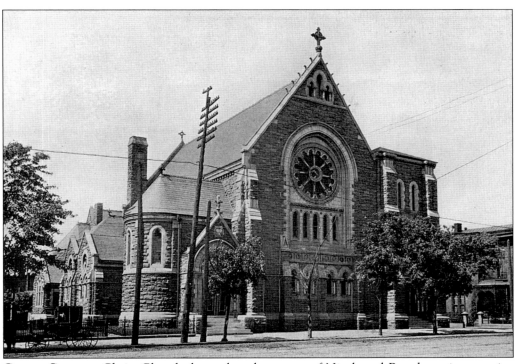

CHRIST CHURCH. Christ Church, located at the corner of Ninth and Broadway, is a massive Gothic-style cut stone church. The church was completed in 1887, but had a tower added in 1947. The exterior stone gargoyles are particularly interesting.

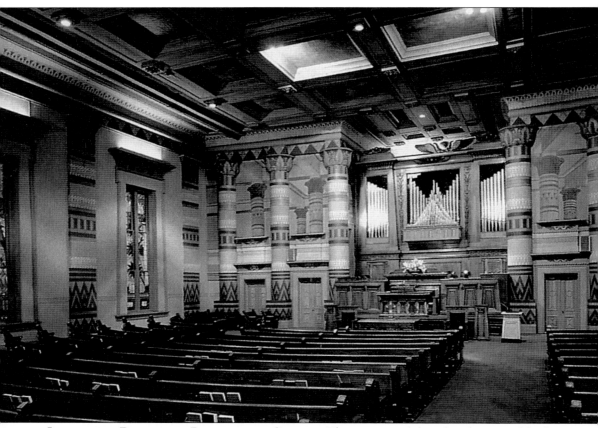

INTERIOR OF DOWNTOWN PRESBYTERIAN CHURCH. The interior of this church is possibly the most beautiful in America. It is certainly the most unusual. The Egyptian decor pictured here is basically unchanged since 1851, except for the addition of electric lights. Note the magnificent organ pipes behind the altar. It is interesting to note that upon more than one occasion, the congregation was condemned by rival sects for conducting services in such an obviously "heathen" structure. (Photo copyright 1991, Richard Southern.)

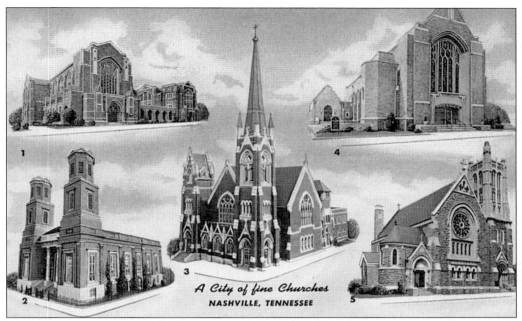

CLUSTER OF CHURCHES. Nashville is a city of many churches. Their interiors are all exquisitely detailed with beautiful woodwork, leaded stained glass, and stunning architectural elements. All of the churches pictured here are still standing except for First Baptist Church, in the center of this postcard. The willful destruction of this remarkable architectural masterpiece in favor of a "more modern" building is unpardonable. Fortunately the steeple was spared, and is still standing on Broadway.

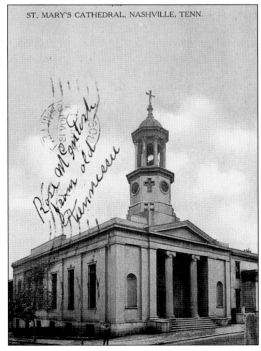

ST. MARY'S CATHEDRAL. St. Mary's Cathedral Catholic Church, as pictured in this 1908 postcard photo, was constructed in 1847 at 330 Fifth Avenue North, and is the oldest continuously standing church building in Nashville. The church's official title is St. Mary's of the Seven Sorrows Catholic Church. Built of cut stone, it contained Tennessee's largest open expanse not supported by columns at the time of its construction. A giant bow-shaped stress beam has provided support for the building for over 150 years. During the War Between the States, the church served as a hospital, and more than 300 injured soldiers, both Confederate and Union, died here.

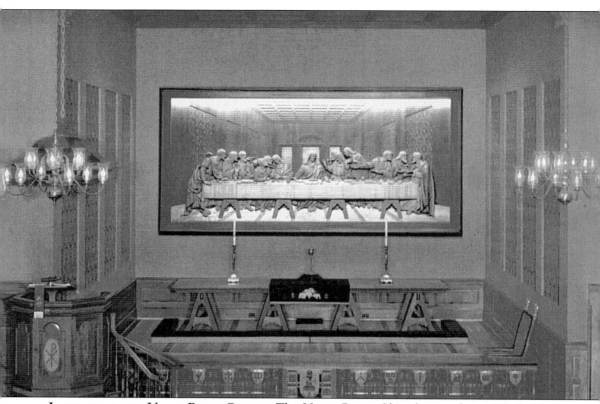

INTERIOR OF THE UPPER ROOM CHAPEL. The Upper Room Chapel opened in 1953, but has been distributing the Upper Room Devotional since 1935. The publication is printed in 40 different languages and distributed to 75 countries. What is most remarkable about the Upper Room Chapel in this image, is its solid wood carving of the Last Supper. This unique and unusual wood carving was created by sculptor Ernest Pellegrini, and is 17 feet long, 8 feet high, and 8 inches deep. In addition to the carving, there is a 20-by-8-foot, 9,000-piece stained-glass window, which depicts the story of the Pentecost.

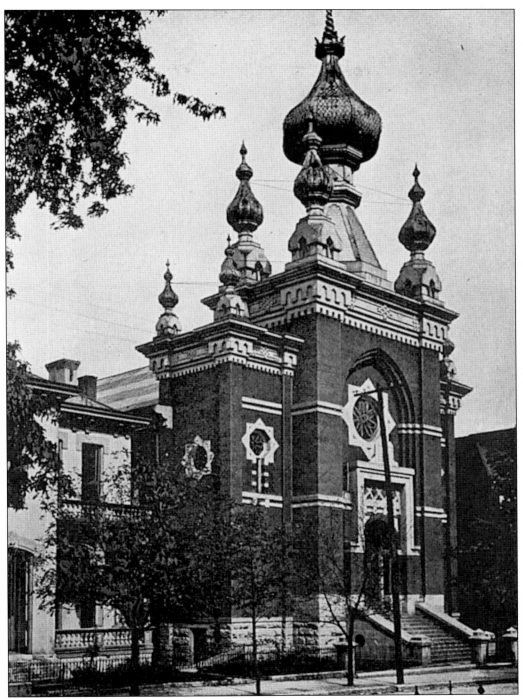

JEWISH SYNAGOGUE. This photo shows the magnificent Vine Street Temple, which stood next door to the Sam Davis Hotel on Seventh Avenue North between Broadway and Commerce. The multi-domed Byzantine structure was completed in 1876 and was the home of the Reform Congregation, which moved to a new facility in 1950.

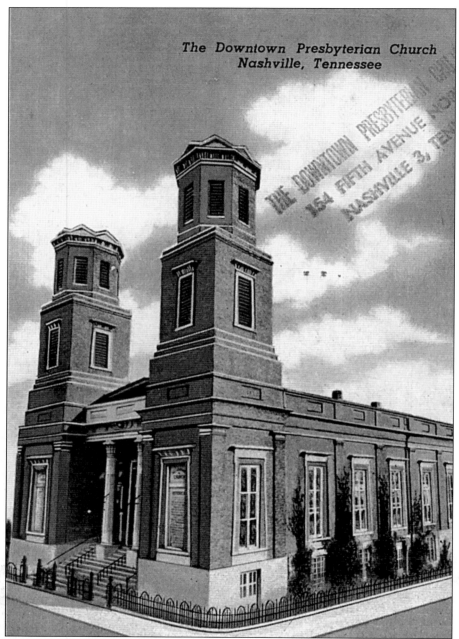

The Downtown Presbyterian Church
Nashville, Tennessee

DOWNTOWN PRESBYTERIAN CHURCH. Without a doubt, this is Nashville's most beautiful church, and the only building of its age still standing on Nashville's once thriving Church Street. Its Egyptian Revival style was designed by William Strickland, who also designed the State Capitol Building. The first two churches on this site burned, but this one was dedicated in 1851. Construction began on this site in 1814, making it the city's oldest church. Upon his triumphant return from the Battle of New Orleans, Andrew Jackson celebrated at this church, which has also seen the inauguration of three Tennessee governors and served as a Union hospital. For many years, its 4,000-pound tower bell served as Nashville's fire alarm.

Eight

NASHVILLE SKYLINE AND STREET SCENES

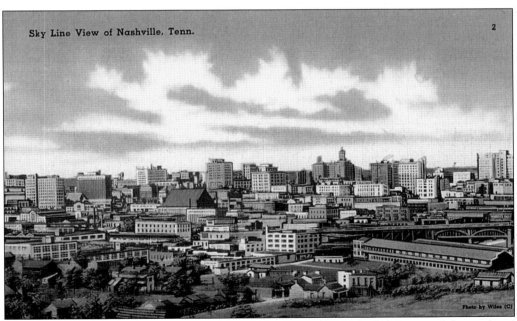

Sky Line View of Nashville, Tenn. 2

Photo by Wiles (C)

SKYLINE VIEW. The Ryman Auditorium's steep roof is visible at the left center of this undated postcard, as is the former Sam Davis Hotel. The area pictured here, below and to the right of the Ryman, is now occupied by the new Nashville Arena, and will also contain the new Country Music Hall of Fame and Museum.

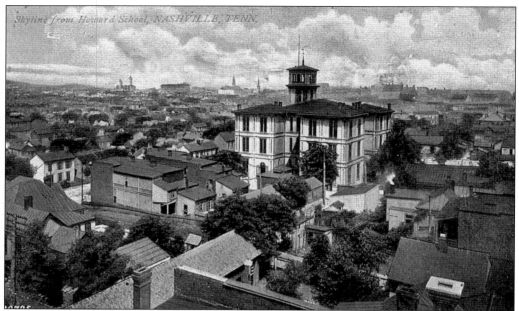

NASHVILLE SKYLINE, VIEW FROM THE OLD HOWARD SCHOOL. In this postcard photo from 1909, several of the old houses pictured to the left have servants' quarters affixed to the rear of the properties, much like most of the houses in the New Orleans French Quarter. Sadly, most of what is seen here has been gone for decades. In fact, throughout the entire downtown area of Nashville, once covered with stately residences, only one townhouse remains.

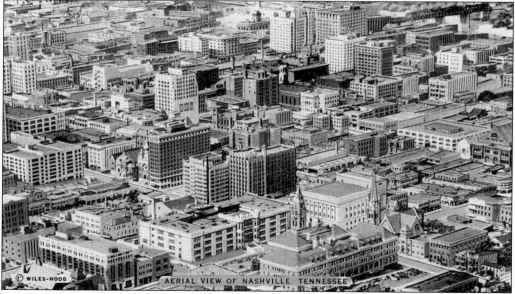

AERIAL VIEW, NASHVILLE. This aerial view of Nashville shows the city at its architectural zenith, prior to World War II. The new post office building, which was erected in 1934, had not yet been built, and the Vine Street Temple is still standing next door to the Sam Davis Hotel (now gone). The Maxwell House Hotel, Bus Station, and several old mansions, as well as a host of other lost buildings, are clearly visible.

80

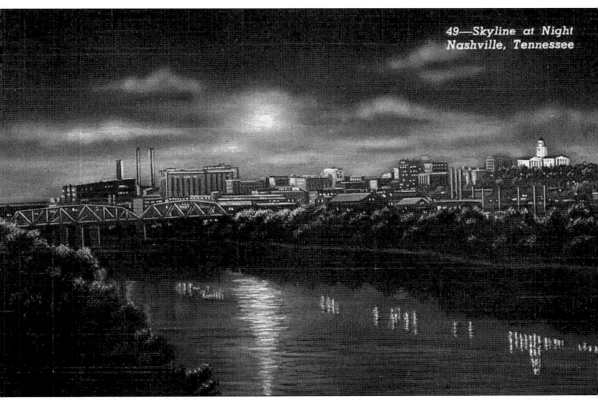

NASHVILLE SKYLINE AT NIGHT. This depiction of the skyline, as viewed from the east bank of the Cumberland River, in no way even slightly resembles the city's current silhouette, except for the ever-present Tennessee State Capitol Building at the far right of the picture.

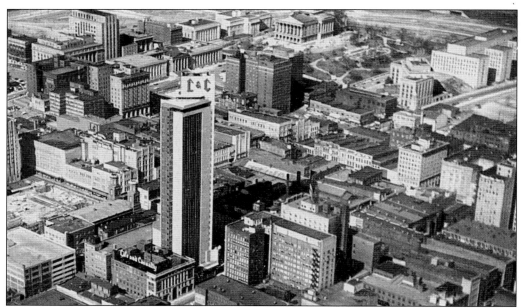

SKYLINE VIEW WITH THE L & C TOWER. The Life & Casualty Tower, Nashville's first skyscraper, clearly dominates this mid-1950s postcard photo of downtown Nashville. At the top of the building, the letters "L & C" are clearly visible. The War Memorial Building appears directly above the letters. The Downtown Presbyterian Church, Harvey's Department Store, and the Tennessee Theatre building are pictured to the left at the base of the L & C Tower.

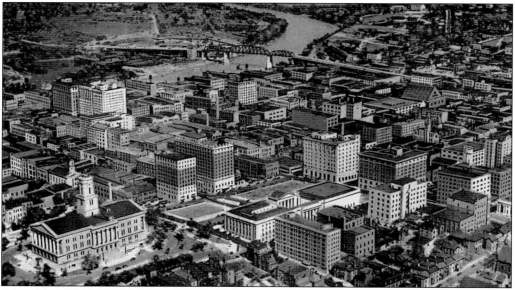

AEROPLANE VIEW OF NASHVILLE. This interesting view of the city, supposedly from an aeroplane, presents the city as seen from the northwest, looking toward the southeast. The familiar landmarks of the State Capitol and Memorial Square are clearly visible in this picture, as are the Andrew Jackson and Hermitage Hotels and the YMCA Building. The two most interesting aspects of this presentation are the absence of buildings on the far side of the river and the presence of a large number of private homes at the bottom center and right of this card.

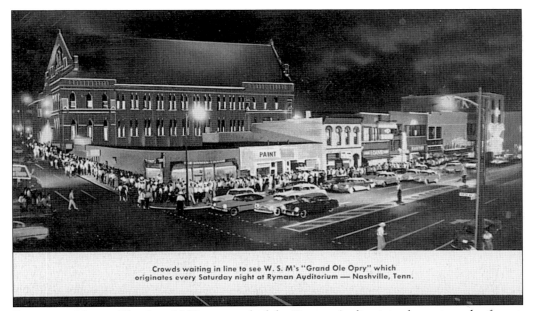

Crowds waiting in line to see W. S. M's "Grand Ole Opry" which
originates every Saturday night at Ryman Auditorium — Nashville, Tenn.

RYMAN AT NIGHT. This late-1950s postcard of the Ryman Auditorium shows it as the former
Grand Ole Opry House. The Grand Ole Opry was broadcast live from this building every
Saturday night from 1943 through most of 1974. This card depicts a large crowd standing in
line waiting for tickets. On Saturdays, the line would always stretch from the Ryman down Fifth
Avenue to Broadway, and often around the corner to Fourth Avenue.

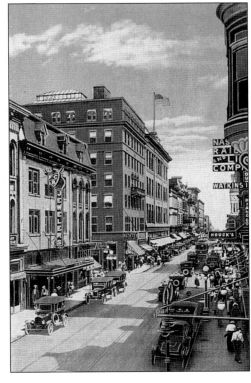

CHURCH STREET LOOKING EAST FROM SIXTH
AVENUE. This scene of Church Street
looking east from Sixth Avenue North was
probably taken in the early 1920s. Nothing
architecturally would give the present-day
Nashvillian any idea that this could have ever
been Nashville's busiest street. Until the end
of the 1960s, Church Street was Nashville's
main retail center. On the middle of the card
to the far right, the Watkins Institute sign
provides the only clue that this might be a
Nashville street.

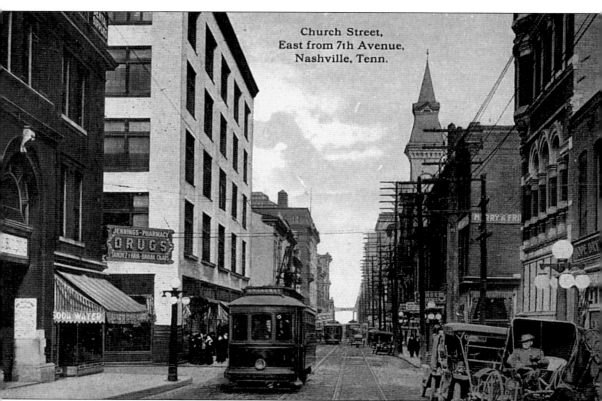

Church Street,
East from 7th Avenue,
Nashville, Tenn.

CHURCH STREET LOOKING EAST FROM SEVENTH AVENUE. In Nashville, street layout was originally fairly easy to follow. The Cumberland River ran through the city from north to south. The city's main street, Broadway, begins at the river's edge, and runs west. As the streets move away from the river, the names increase in number. This is the same scene as on the previous page, but from Seventh Avenue, a block farther away from the Cumberland River.

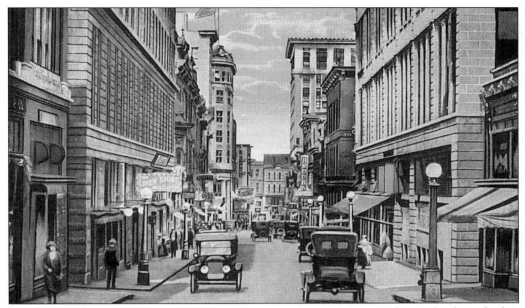

UNION STREET. Union Street was Nashville's Wall Street, and contained many banks and other financial institutions.

CHURCH STREET LOOKING WEST. This 1940s scene of Church Street represents downtown Nashville at its architectural zenith. The Doctors Building is the tall white building in the center of the image. In those days, everything was located downtown, including most of the theatres, all of the hospitals and doctors' offices, and most restaurants and retail stores. On Saturdays, people from outlying areas, such as Franklin, Dickson, Centerville, and Murfreesboro, as well as locals, would flock to downtown.

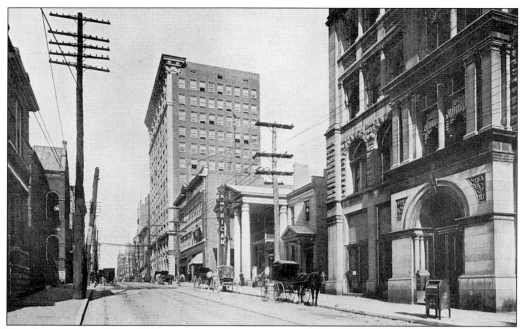

FOURTH AVENUE. This 1900-era photo shows Fourth Avenue North, as seen from Commerce Street. Today, the buildings on the right have been replaced by another skyscraper, and the horse-drawn carriages have vanished. Fourth Avenue is now a one-way street, with traffic moving in the direction of this photograph.

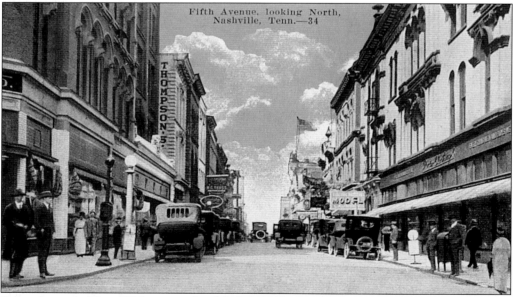

FIFTH AVENUE. This 1920s postcard is labeled "Fifth Avenue, Looking North." The structure to the left appears to be the building that would eventually house Harvey's, which was at one time Nashville's largest department store. Most of the buildings pictured on the right side of this card are long gone, among them a Krystal, the Russel Stover Candy store, and the Fifth Avenue Cigar Store. The buildings pictured to the left are still standing.

86

FIFTH AVENUE NORTH (LOOKING SOUTH). The previous postcard photo depicts Fifth Avenue North looking north toward Union. This is the same block of Fifth Avenue North, but seen from Union Avenue, looking south toward Church Street. This 1908 scene shows Nashville's original cobblestone streets, and includes to the right what was then probably one of the city's only cars.

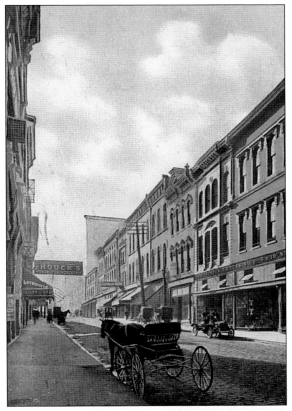

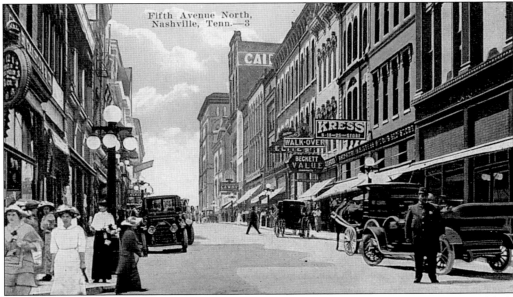

FIFTH AVENUE NORTH (LOOKING SOUTH). This is the same scene as above, but most likely taken 20 years later. One can see the development of commerce in this relatively short period of time, as well as the newly paved street.

THIRD AVENUE. This picture of Third Avenue North as seen from Church Street was taken prior to the widespread arrival of automobiles in Nashville. You will, however, note the steel trolley rails in the center of the street. Electric trolleys were the first modern form of public transportation in the city.

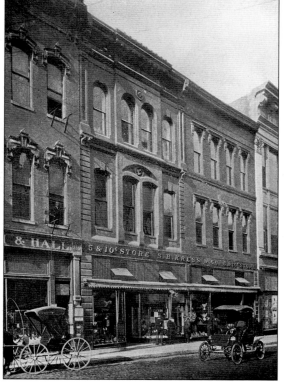

KRESS COMPANY. This photo is labeled simply "S.H. Kress Company's Five and Ten Cent Store." With this limited information, it is difficult to tell where the store actually was located. This Kress store very obviously predates the one still standing on Fifth Avenue North, erected most likely in the early 1920s. This photo, probably taken prior to 1910, shows the interesting juxtaposition of the horse-drawn and mechanical ages.

Nine

HOSPITALS AND EDUCATION

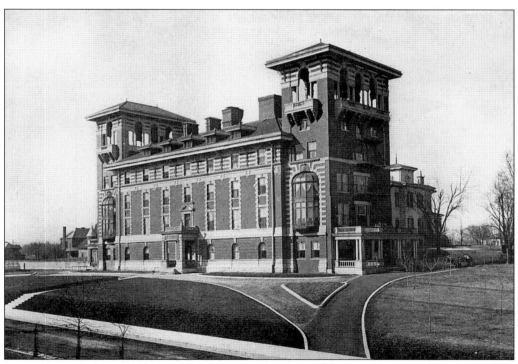

ST. THOMAS. This stark photograph of St. Thomas Hospital does little to inspire comfort. This was the first phase of the hospital that stood on Twenty-first Avenue and Hayes Street. It was established by Bishop Thomas Byrn and was operated by the Sisters of Charity. The sisters of the hospital wore large, starched-white hats that resembled futuristic paper gliders.

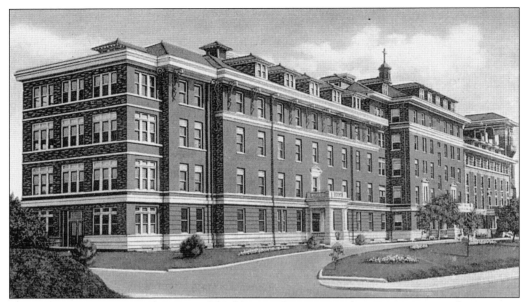

ST. THOMAS HOSPITAL. The original building underwent much improvement and expansion over time, as noted in this larger more modern postcard. By the early 1970s, this frightening building had been torn down, the land taken over by Baptist Hospital across the street, and St. Thomas moved to a gigantic new state-of-the-art hospital on Harding Road, about 7 miles west of downtown Nashville.

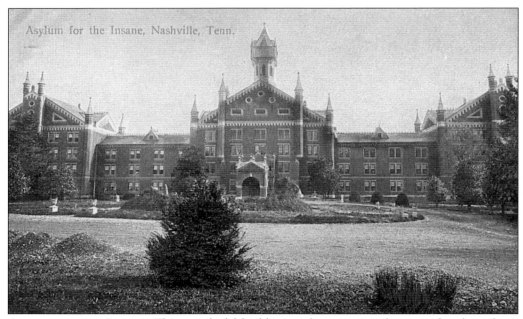

Asylum for the Insane, Nashville, Tenn.

ASYLUM FOR THE INSANE. This wonderful building no longer exists, but is said to have been located on Murfreesboro Road across from the Colemere Club on land recently purchased by Dell Computers.

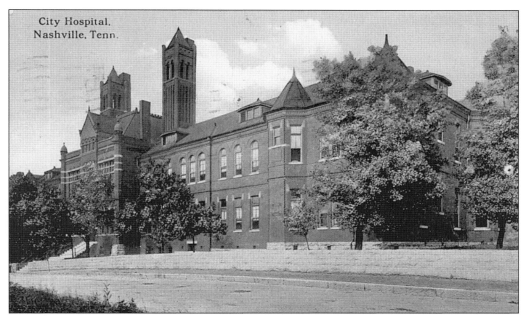

CITY HOSPITAL. This postcard showing the City Hospital located on Hermitage Avenue is postmarked 1913. "City" served as Nashville's main public hospital for years, and eventually became General Hospital, and finally Metropolitan General.

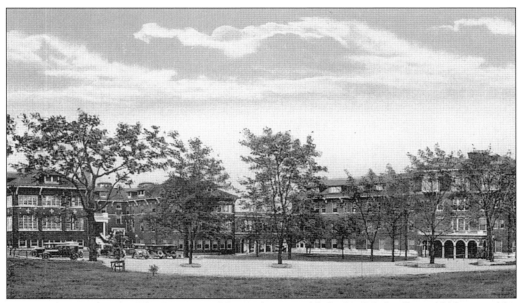

PROTESTANT HOSPITAL. The Protestant Hospital was established in Nashville in 1918 as a public welfare institution caring for the afflicted and for the training of nurses. Despite the apparent size of this hospital, it only accommodated 100 patients. This building, located at Twenty-first Avenue and Elliston Place/Church Street, eventually became the Baptist Hospital, which ultimately expanded to the property across the street, which was, at the time of this photo, occupied by St. Thomas Hospital.

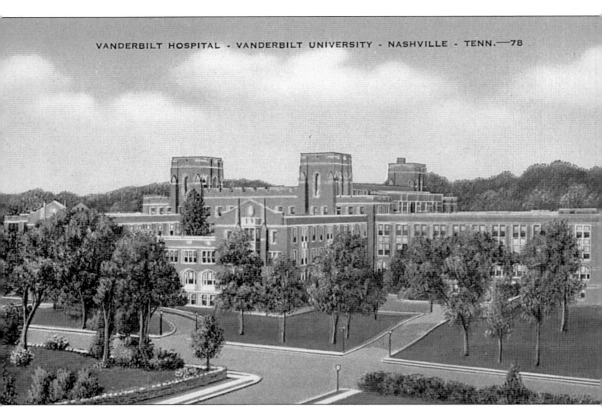

VANDERBILT HOSPITAL. Vanderbilt Hospital is part of the Vanderbilt University School of Medicine. At the time of this postcard, the 200-bed hospital consisted of nine buildings assembled under one roof. Within the hospital building at this time were the medical school laboratories, a medical library, lecture and classrooms, out-patient facilities, and administrative offices.

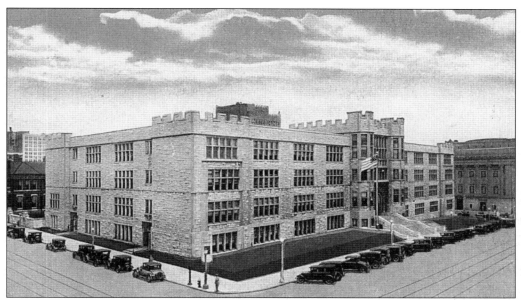

HUME-FOGG HIGH SCHOOL. The heavy stone Hume-Fogg High School building, as pictured here, served as a senior high school for 1,500 students and 59 teachers. Originally, the building, constructed between 1912 and 1916, consisted of the center section and only one of the two extended wings. The matching wing was added later. Today, Hume-Fogg is an arts magnet school and remains a prominent Nashville landmark, as it has been for nearly 90 years. Among its many famous students were pin-up queen Bettie Page and actress/singer Dinah Shore.

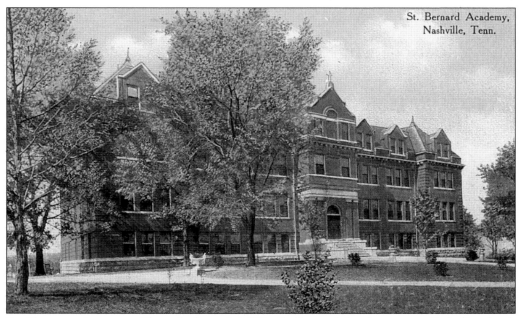

St. Bernard Academy,
Nashville, Tenn.

ST. BERNARD ACADEMY. Through the early 1980s, St. Bernard Academy was a Catholic school. This remarkable building, located on Hillsboro Road, is now an office building situated near restored apartment buildings.

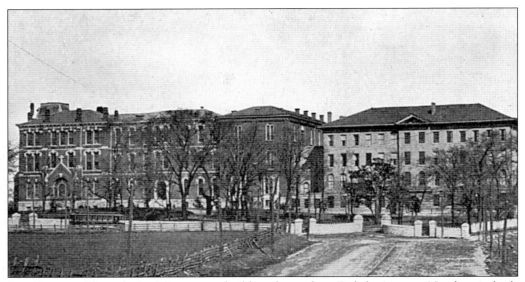

St. Cecilia. The massive three-story building located at Eighth Avenue North was built between 1860 and 1862, during the War Between the States. It served as an academy for girls before the school moved to the Overbrook School property on Harding Road in 1957. Today, the elegant building serves as a residence for nuns.

University of Nashville. The large cut-stone building, which served as the University of Nashville, eventually housed the Children's Museum between 1944 and 1973. The children's museum closed and reopened as the Cumberland Science Museum at the bottom of the hill containing the ruins of Fort Negley.

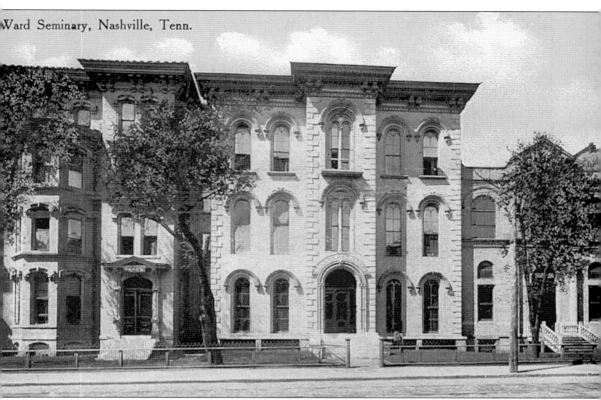

WARD SEMINARY. These next several images portray various aspects of what is now known as Belmont University. This beautiful building was the home of Ward Seminary, which was established in Nashville in 1865. The school would eventually occupy the Acklen's Belmont Mansion, and be renamed Ward-Belmont after a consolidation with Belmont College.

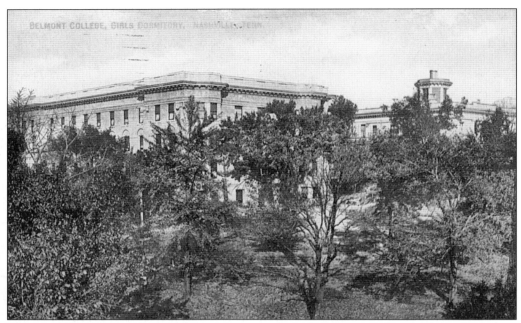

BELMONT COLLEGE FOR GIRLS. This card, postmarked 1910, is especially significant because it represents Belmont College in its first academic usage. This scene is from the brief time after it was acquired from Adelicia Acklen's estate, but before it became Ward-Belmont.

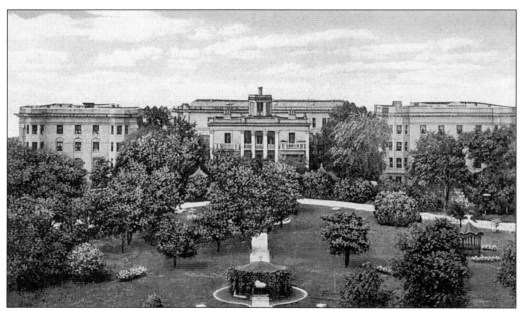

WARD-BELMONT CAMPUS AND MAIN BUILDING. This view of the Ward-Belmont campus shows Belmont Mansion as the center building, with classroom and administrative buildings on both sides. The cast-iron gazebos in the foreground date from the 1850s and are part of the mansion's original landscaping. Ward-Belmont College for Girls had a boarding school enrollment of 500 female students at the time this photograph was made.

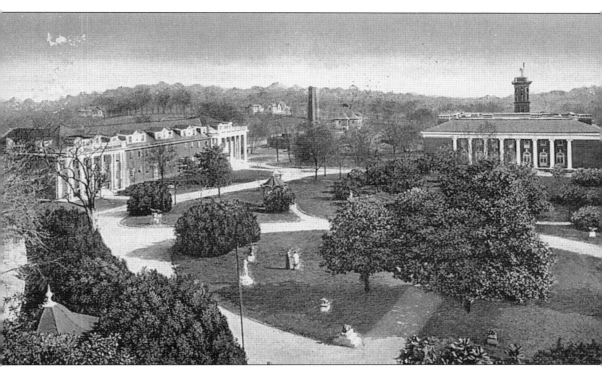

WARD-BELMONT-PEMBROKE HALL AND ACADEMIC BUILDING. This later postcard, postmarked 1916, shows the extent to which Ward-Belmont grew during the preceding decade. This view, most likely from the mansion, shows Pembroke Hall, now a dormitory, on the left, and the Academic Building to the right. The tower appearing to rise from the top of the Academic Building is really a free-standing reservoir and bell tower located behind the Academic Building. By the time this image was produced, Ward-Belmont had students from 30 states and was the largest college for women in the South. Its most famous graduate was Minnie Pearl.

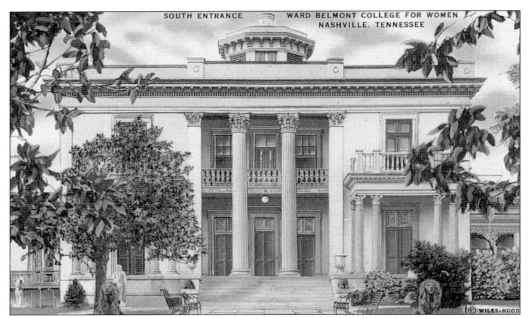

BELMONT MANSION. The Belmont Mansion is certainly one of the most beautiful homes in America. It was erected between 1841 and 1850, but was sold in 1889, after the death of its owner, Adelicia Acklen. A year later it opened as Belmont College, surviving as that for more than 20 years before being sold to the owners of Ward Seminary. While it does not physically resemble Louisiana's famous San Francisco, it has a similar feel. Today, this mansion is part of Belmont University and is open to the public.

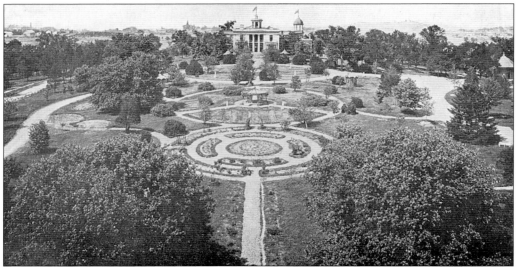

BELMONT COLLEGE. This photo taken from the tower shows the mansion and its original grounds much as they were prior to 1900. That this mansion has survived at all in Nashville is probably due to the fact that it became part of an educational institution within the first 50 years of its existence. This was a mansion, not a working plantation, and is without doubt as elaborate as anything ever built in the fabled Mississippi Valley prior to the War Between the States.

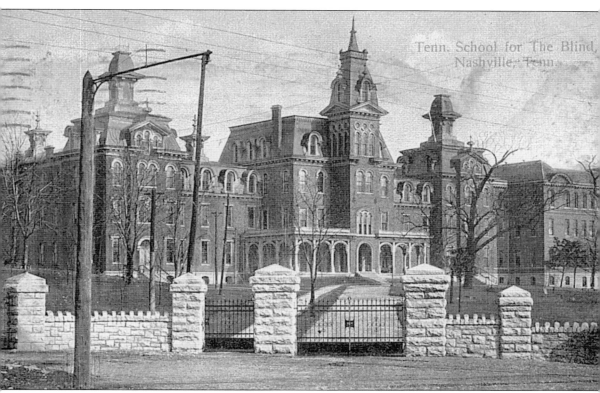

SCHOOL FOR THE BLIND. This beautiful but ominous building, as pictured in this 1909 card, was located on Lebanon Road.

BOSCOBEL COLLEGE. Boscobel College flourished in the 1890s as a college for young women. The elaborate mansion pictured here to the right was regrettably razed to create the James Cayce housing projects.

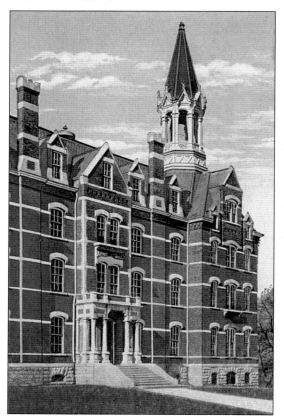

JUBILEE HALL. Under the direction of the American Missionary Association, Fisk University opened in 1866 and was named in honor of Union officer General Clinton Fisk. Jubilee Hall, pictured here, was dedicated on January 1, 1886, named for the internationally famous Fisk Jubilee Singers, who took Negro spirituals around the world, performing for England's Queen Victoria, among others.

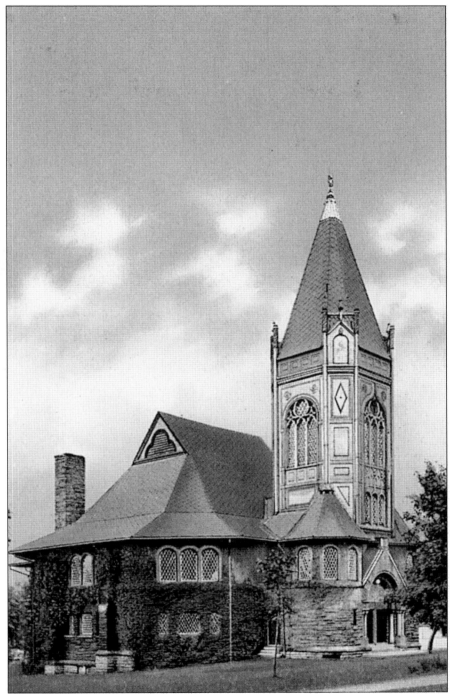

MEMORIAL CHAPEL. The Fisk Memorial Chapel was built from a legacy of Union General Clinton Fisk. At the time this photo was made, Fisk offered several different degree programs. The Fisk campus houses the Van Vechten Gallery, which owns and displays, among other cherished works, some of Georgia O'Keefe's most famous paintings.

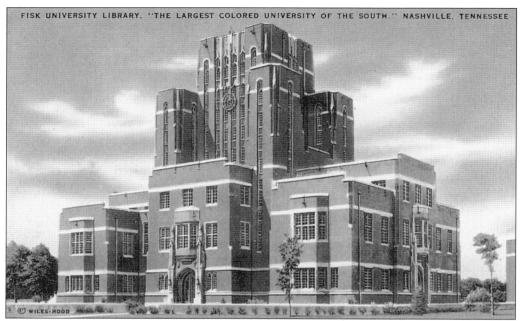

FISK UNIVERSITY LIBRARY. This postcard depicts the Fisk University Library, an amazingly symmetrical and beautiful multi-story Art Deco masterpiece. The card simply refers to Fisk as "The Largest Colored University in the South."

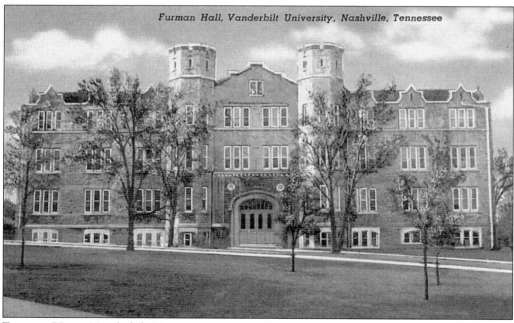

Furman Hall, Vanderbilt University, Nashville, Tennessee

FURMAN HALL. Vanderbilt University was established in 1875, with a donation of $1 million from financier Cornelius Vanderbilt. Furman Hall, pictured here, looks like a castle.

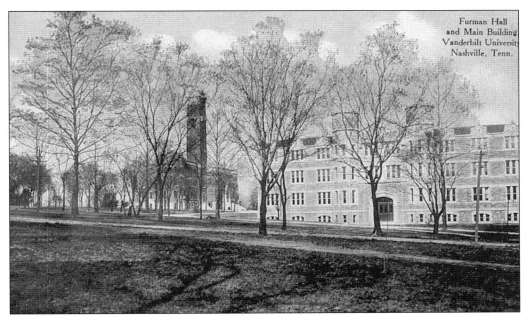

FURMAN HALL AND MAIN BUILDING. This postcard shows Furman Hall and its location on campus in relation to Kirkland Hall.

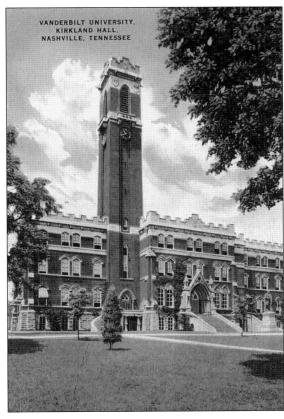

KIRKLAND HALL. The Gothic-looking Kirkland Hall opened in 1875, but was heavily damaged in a 1905 fire. It was subsequently rebuilt.

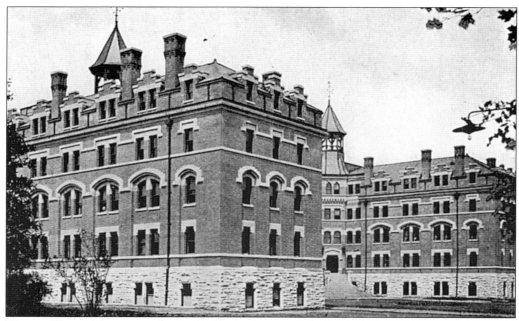

Kissam Hall. This magnificent building, constructed in 1908, served as a 200-capacity dormitory with a cafeteria in the basement. It was razed in 1958.

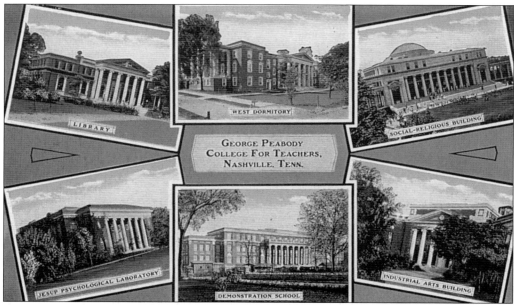

Peabody Cluster. This cluster of five buildings shows the most easily recognized landmarks from the George Peabody College for Teachers campus. The roots of Peabody, as it is called, go back to the founding of Davidson Academy in 1802. Davidson Academy became Davidson College, then Cumberland College before closing in 1816 for financial reasons. It reopened in 1822, and then became the University of Nashville in 1826. Subsequently, one of its branches became George Peabody College for Teachers, and the campus moved to its present location in 1911.

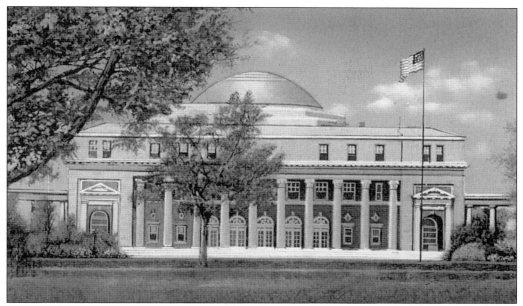

SOCIAL-RELIGIOUS BUILDING, C. 1940S. The Social-Religious Building, located upon the grounds of George Peabody College for Teachers, has long been the building most readily associated with the institution. It is clearly visible today from its location at Twenty-first Avenue South.

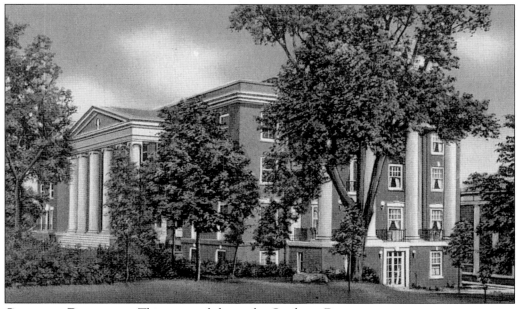

GRADUATE DORMITORY. This postcard shows the Graduate Dormitory.

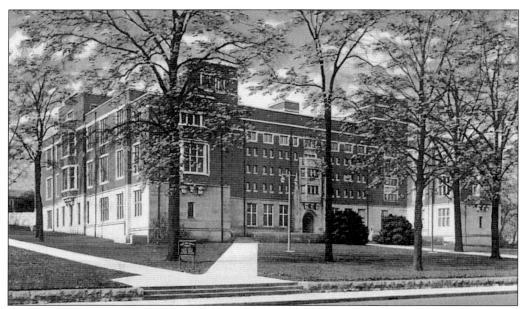

JOINT UNIVERSITY LIBRARY. At the time of this postcard, the Joint University Library was shared by students of Vanderbilt University, Scarritt College, and the George Peabody College for Teachers. In 1979, Peabody College became a part of the Vanderbilt University system.

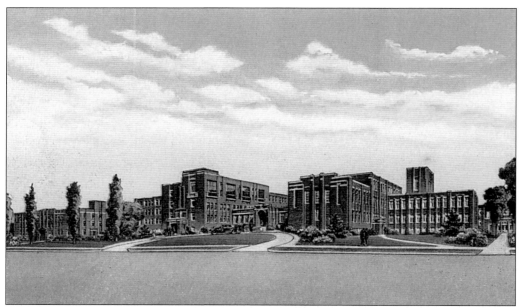

MEHARRY MEDICAL COLLEGE. Meharry Medical College was founded in Nashville in 1876 as a medical, dental, and nursing school for black scholars. During more than a century of service, it has educated more black dentists and doctors than any other institution in America. This postcard, postmarked 1951, celebrates a half-century of progress in the form of the newly completed plant.

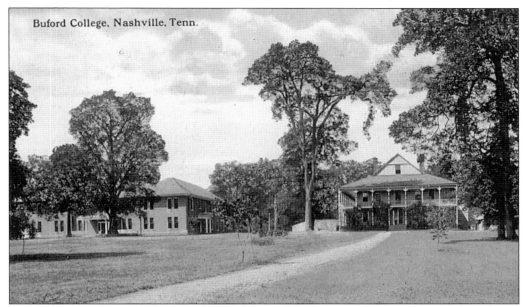

Buford College, Nashville, Tenn.

BUFORD COLLEGE. This 1913 postcard depiction of Buford College is one of the few remaining images of this former Nashville institution of higher learning. Buford was a "non-sectarian, non-denominational, but thoroughly Christian" college for women with an enrollment limited to 100 students. It was located on 25 acres in an area behind David Lipscomb University. Its catalogue described Nashville as a "City of Rocks" with a "salubrious climate." Pictured here are the college's two buildings: Burgess Hall, on the left, and the Home Building, which served as the college boardinghouse.

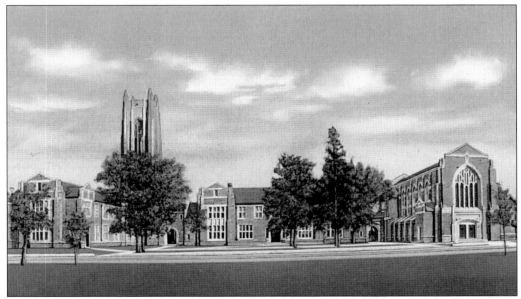

BENNETT MEMORIAL. The Scarritt College for Christian Workers' Belle Harris Bennett Memorial was dedicated in 1928 as a gift of the women of the Methodist Episcopal Church, South.

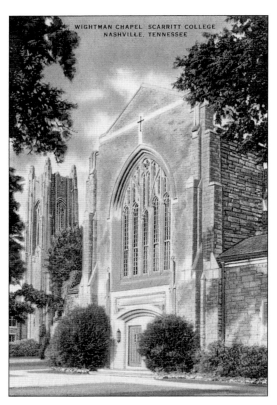

WIGHTMAN CHAPEL. The chapel, located on Nineteenth Avenue, is part of the Bennett Memorial.

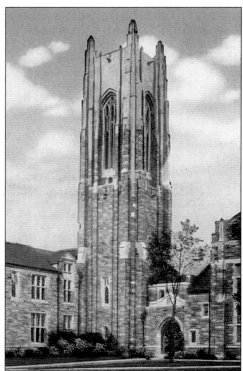

THE TOWER. The Tower at Scarritt is the most recognizable feature of this pleasant campus located in the Music Row-University area.

Ten

MISCELLANEOUS

FORT NEGLEY. The caption for this 1910-era photo says that Fort Negley "was the scene of desperate fighting during the Civil War." Actually, the Battle of Nashville took place well beyond the range of the massive fort's guns. The Union fort was built by impressed slave labor under orders from General John Negley in 1862.

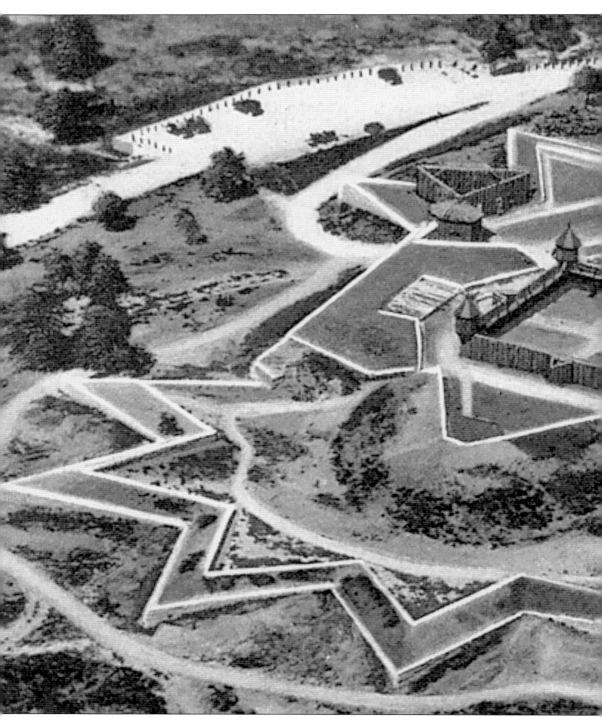

FORT NEGLEY. According to the information on the back of this card, Fort Negley has been perfectly restored to its original configuration in this postcard view. The fact is that Fort Negley looks nothing like this at all. What little of it remains is buried in a thicket of weeds, brambles,

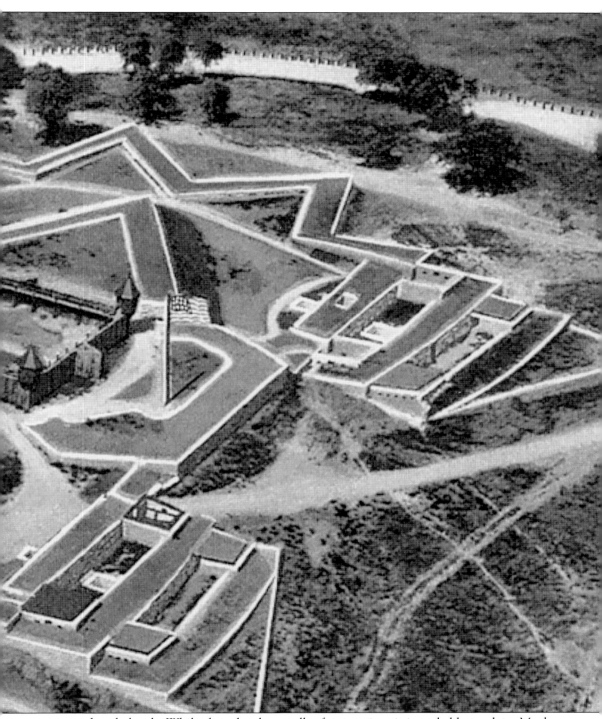

trees, and underbrush. While there has been talk of restoration, it is probably too late. Much of the stone that was used to build the fort was supposedly removed for building the reservoir around the corner on Eighth Avenue.

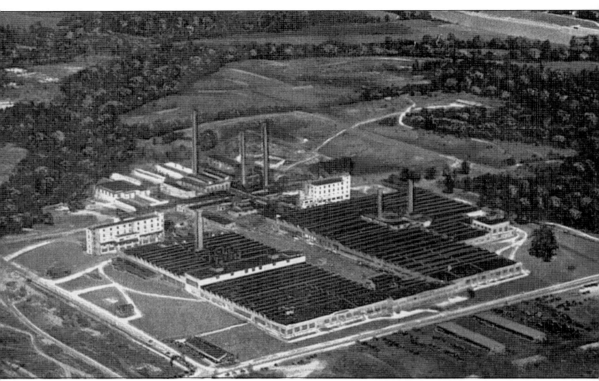

RAYON CITY. This area of town, which was reached by way of Gallatin Road, was formerly the town of Old Hickory, and considered to be somewhat rural despite the presence of the Dupont Rayon Company pictured here. Today the area is part of Nashville and generally known as Old Hickory, while the specific vicinity of the plant is called "Rayon City" by locals.

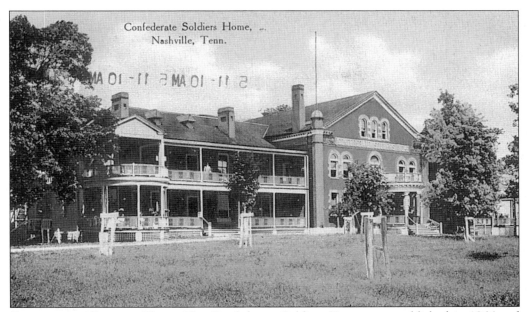

CONFEDERATE SOLDIERS HOME. The Confederate Soldiers Home was established in 1866 and located on 25 acres of land that were originally part of Andrew Jackson's Hermitage.

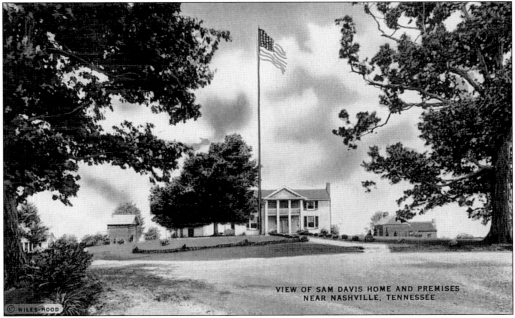

VIEW OF SAM DAVIS HOME. Confederate hero Sam Davis is seldom mentioned, if at all, in Tennessee history anymore, although the values for which he willingly sacrificed his life, when given the choice to betray his comrades and live, or die a hero, are as important today as then. This postcard shows his house and grounds near Smyrna, just outside Nashville.

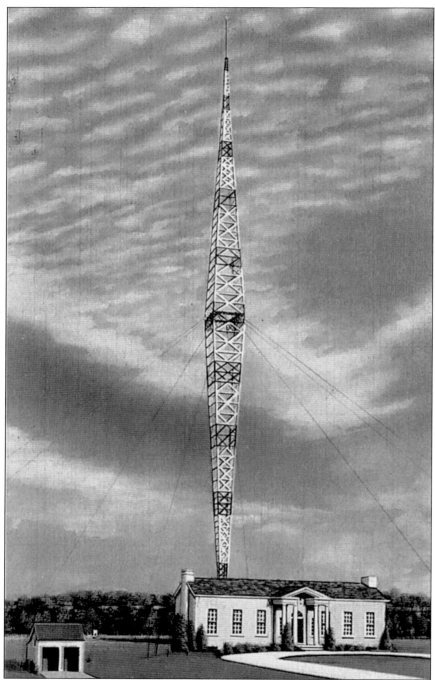

WSM Radio Broadcast Tower. WSM stands for "We Shield Millions," the motto of the National Life and Accident Insurance Company, which owned WSM Radio, the Grand Ole Opry, and many other properties. At one time, this 878-foot tower was the tallest radio tower in America. WSM Radio broadcast 18 hours a day and featured 225 artists, who received more than 50,000 fan letters a week.

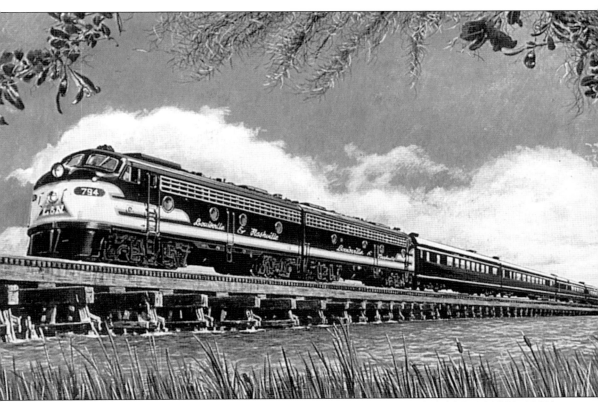

THE HUMMING BIRD. During the golden age of American passenger railroad (about 1900–1950), trains frequently had names like the *Southwind*, *City of New Orleans*, and other similar titles suggesting grace, motion, or dignity. This 1950s-era postcard depicts the Louisville & Nashville Railroad's famous *Humming Bird* en route, presumably crossing Lake Pontchartrain on the way to New Orleans.

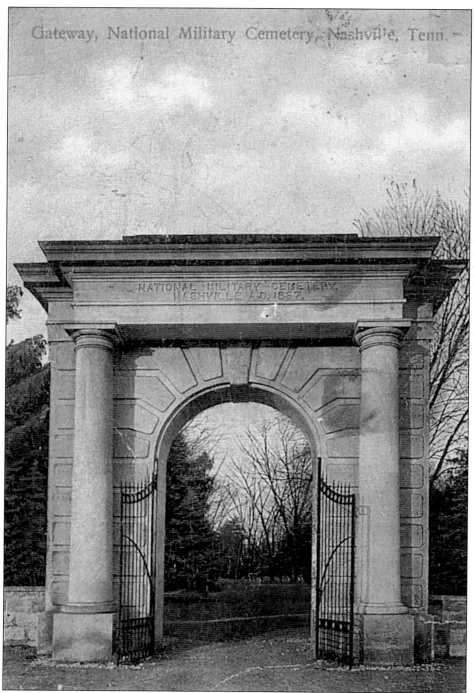

Gateway, National Military Cemetery, Nashville, Tenn.

NATIONAL MILITARY CEMETERY.
NASHVILLE A.D. 1867.

NATIONAL MILITARY CEMETERY. This 1910 postcard shows the main entrance to the National Military Cemetery, located on Gallatin Road about 10 miles from downtown Nashville. At the time this cemetery was established, it was considered to be way out in the country. Nobody ever imagined that Nashville would extend this far from downtown.

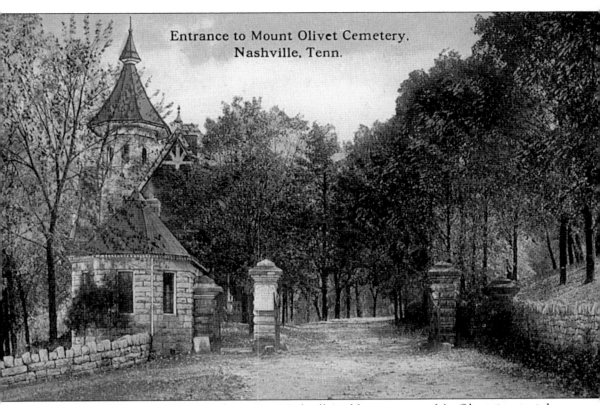

Entrance to Mount Olivet Cemetery,
Nashville, Tenn.

MT. OLIVET CEMETERY. Although it is not Nashville's oldest cemetery, Mt. Olivet is certainly the city's most interesting. Located on Lebanon Road just outside of downtown Nashville, the cemetery sits atop a hill in a beautiful, pastoral setting. The ornate marble, granite, and bronze monuments, tombs, and crypts are some of the most unusual and elaborate in America. For nearly the past century and a half, Nashville's most distinguished citizens have been buried here. The cemetery, which opened in 1856, contains the remains of nearly 200,000 persons.

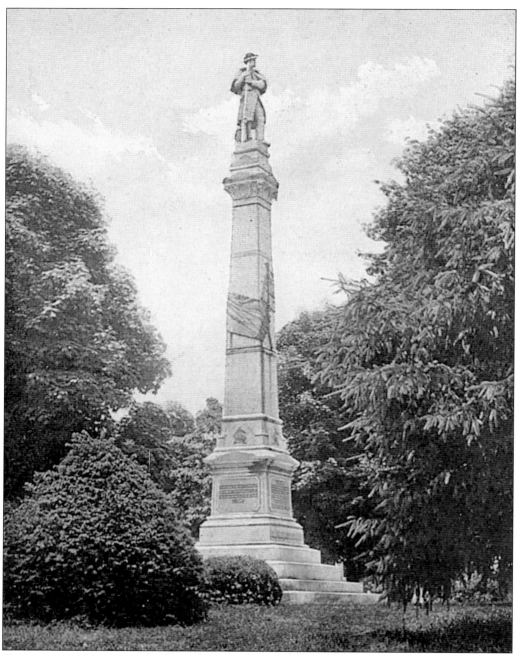

CONFEDERATE MONUMENT. This 45-foot granite monument within Mt. Olivet's grounds is located in the area of the cemetery known as Confederate Circle. The circular plot of land was purchased in 1869 by the Ladies Memorial Society of Nashville, and contains the remains of some 1,500 Confederate soldiers who died in Nashville-area battles.

CHURCH STREET MANSION. This photo from the Tennessee State Archives shows an old mansion typical of those that occupied West End, Elliston Place, and downtown. This one was said to have been located on Church Street on the spot occupied by either the Doctors or Bennie Dillion Building today.

WEST END MANSION. This was the last in a long line of incredible private residences in the area of Thirty-second Avenue and West End. Gradually throughout three decades, these fabulous houses were replaced by apartment and office buildings. This last house had been separated and used for several years as an apartment building. As is customary for older buildings in Nashville, a for-sale sign was followed by a mysterious fire, and the building was invariably too far gone to restore. Today, an Outback Steakhouse occupies this spot.

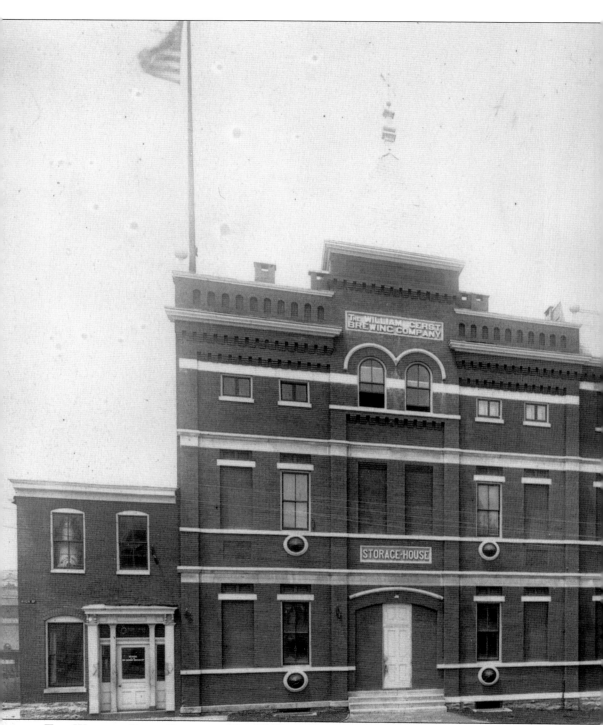

THE WILLIAM GERST BREWERY. The William Gerst Brewery was established in 1865 on a 4-acre tract at Sixth Avenue and Mulberry. It produced a variety of beers and ales, and survived through Prohibition by bottling various soft drinks. A horse owned by the Gerst family named

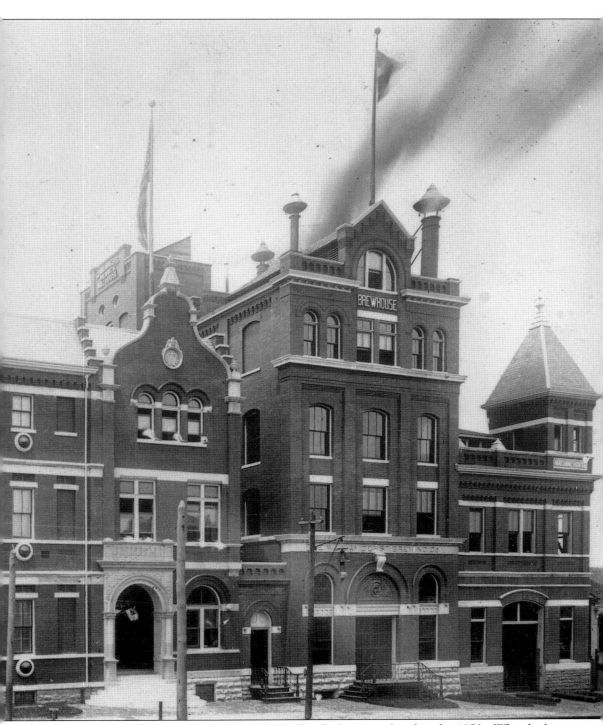

Doneau won the Kentucky Derby in 1910. Finally, the brewery closed in the 1950s. What little remained of the brewery burned in the early 1990s.

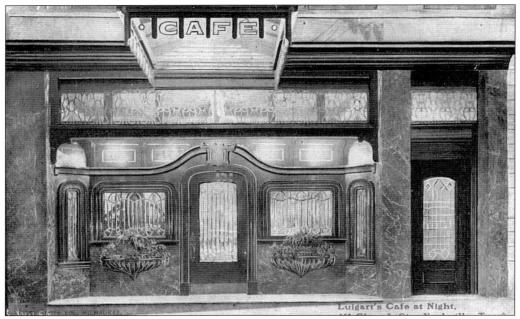

LUIGARTI'S. This 1911 postcard shows Luigarti's Café, which was located at 411 Church Street.

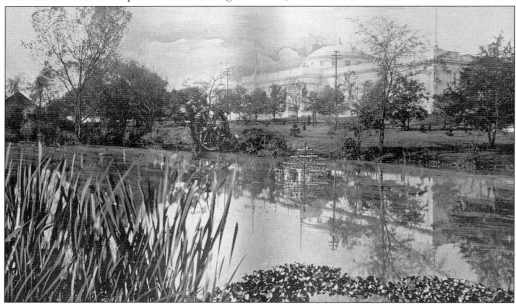

FIRST GLIMPSE. The following images, printed by Marshall & Bruce in 1898, were taken from a booklet that was printed a year after the exposition, which took place in Nashville from May 1 to October 31, 1897. The text included here is the same that appeared in the booklet. In this view, a grand vista greets visitors at the entrance gate. Visible far away to the right are the camps among the trees, the white tents gleaming in the soft sunlight. In the foreground is the lovely little Lake Katherine, whose silver surface was an attraction never to be forgotten. The bridge and the old water wheel, the topics of universal interest, are recalled, while just beyond, through the trees, one can catch a partial view of the Government Building.

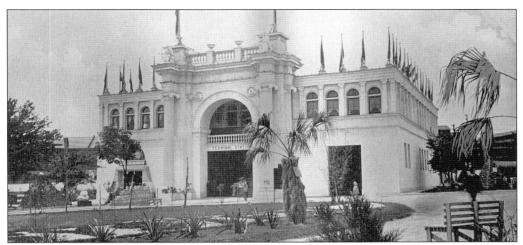

RAILWAY ENTRANCE. This ornamental terminal station was located at the site where the tracks of the Nashville, Chattanooga & St. Louis Railway entered the grounds. One hundred feet square and exquisitely designed, this building contained an entire exhibit of the products of the soil along the railway line whose enterprise erected it, and was a complete little exposition in itself—a lasting monument to the enterprising line which placed it there.

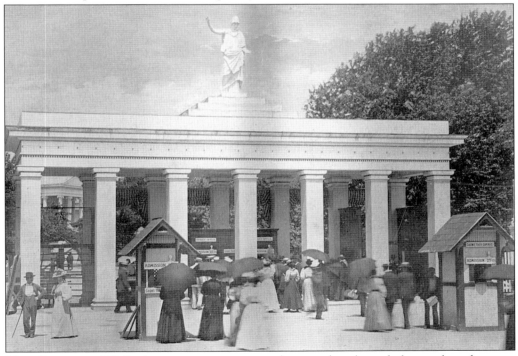

MAIN ENTRANCE. While there were two entrances that were largely used, the number who came in at the streetcar entrance, or main entrance, was fully three-fourths of the total attendance. The first view, therefore, shows this gate, plain, but ornamental, and a fitting introduction to the wonders beyond. The entrance is surmounted by a statue of Pallas Athene—an exact copy of the famous Pallas Velatrix made in Paris by Miss Enid Yandell of Louisville, Kentucky. Beyond the gates lies all the wonder of the exposition.

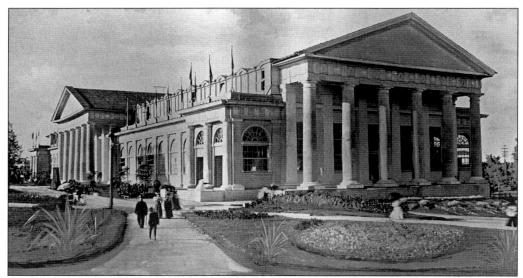

MINERALS AND FORESTRY BUILDING. Passing along the main walkway, one comes to the front of the imposing Minerals and Forestry Building, a stately and substantial structure. Of the Roman-Doric order of architecture, it had plentiful space, as well as a display of Tennessee products that was astonishing even to Tennesseans. Its three porticos, the six columns in each crowned with sculptured gables, gave an added interest in every way to the building, and made it one of the most notable of the exposition structures. Along the front were beds of the choicest flowers.

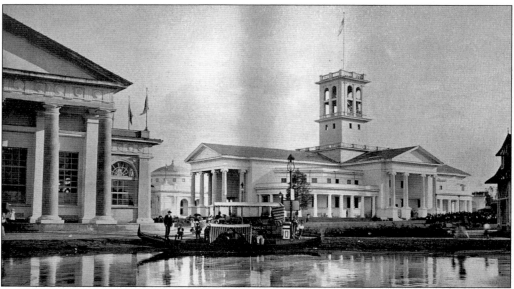

THE AUDITORIUM. On the left stands the auditorium, a building held in loving remembrance by all that are fond of the highest music. Here the exercises incident to the special days were had, and here the greatest bands of the country played their sweetest music for weeks, at times to crowded seats. The opening exercises and celebration of the State Centennial, held on June 1, 1896, were the first to be had here, but there was no day after the exposition opened that one could not see grand concerts and other forms of entertainment in this great hall.

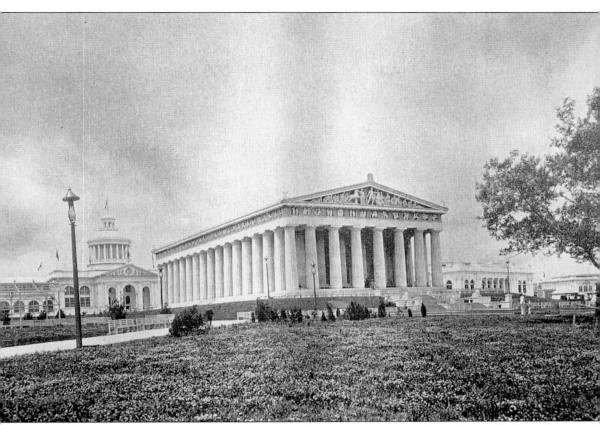

THE PARTHENON. Turning the corner around the auditorium one comes upon the first full view of the architectural and artistic center of the exposition, the Parthenon. Reproduced in all of its original lines and colors, this building stands as a monument to the talent and appreciation of the gentlemen who were instrumental in its reproduction. Glorious and inspiring, its beauties grow with each succeeding visit, and the visitor soon finds himself unconsciously making the art building the one place to be first seen. That it will remain standing is a credit to Nashville and to the South.

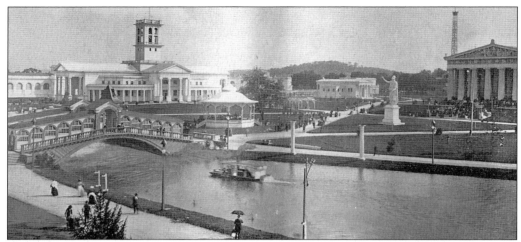

THE RIALTO. The first view of the Rialto is an interesting one, especially at night, when the brilliant illuminations are reflected in the water below, throwing back a thousand variations. An exact copy of the famous bridge in Venice, no better design could have been conceived to span the lake at the entrance to Capitol Avenue. Thousands crossed it day and night, and its picturesque details never wearied the visitor, with whom it was a favorite place to stop and view the expanse of park, which stretched away to the north.

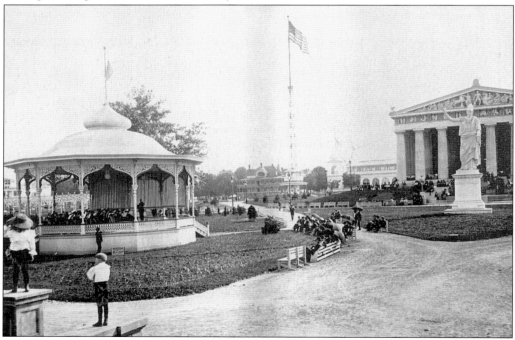

VIEW FROM THE RIALTO. One of the pretty views from the Rialto shows the grand bandstand in the foreground, the Bellstedt-Ballenberg Band giving an afternoon concert in the open air. The time is May, and the look of springtime is in the air. To the right stands the gigantic statue of Pallas Athene, and beyond is all that section of the grounds which lies between the Rialto and the Parthenon. This was a place from which many good views were to be had, and this one example will recall many others to the visitor. Let us now cross the Rialto towards the east.

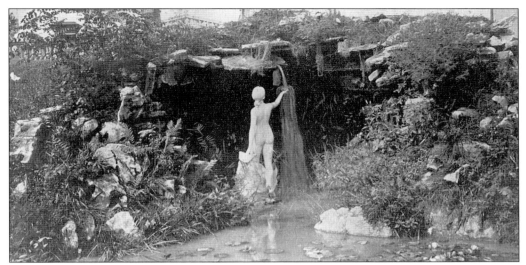

PURITY GROTTO. Just below the Rialto is one of the choicest bits of artificial scenery ever devised by the landscape gardener. In a little cave, or grotto, surrounded by ferns and wild flowers, stands a figure of a beautiful girl, clothed only in her native modesty as the water trickles over her from above. Unconscious of external admiration, she holds up a shell into which the water falls and is beaten into a spray that falls about her form as a fleecy veil. Water lilies—red, white, and blue—grown around the pool, and mossy, flowered banks surround the grotto.

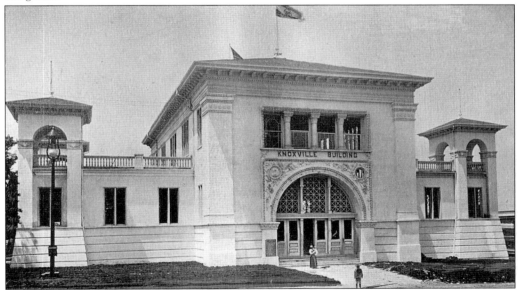

KNOXVILLE BUILDING. The largest of all the structures on Capitol Avenue was the Knoxville Building, a building that was a splendid monument to the enterprise of the mountain metropolis. When their county refused to do its duty, the City of Knoxville took up the work of commemorating the past history and present achievements of East Tennessee by erecting this beautiful structure. It was filled with the products of Knoxville industry, and was at all times a delightful resort for the people of that city, as well as for the casual visitor. Many pleasant meetings were held there.

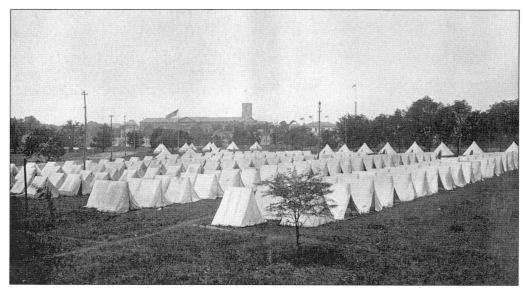

SOLDIERS IN CAMP. This is the camp where the soldiers were quartered during most of the exposition period. Their white tents glisten in the sunlight among the trees, and the bright uniforms of the sentinels flash in the summer afternoon. In the late afternoons, when the dress parade brings out the boys in their best and gayest attire, great crowds of admiring spectators gather to applaud. And at night, when the social side of life is uppermost, the dances in the New York and Knoxville Buildings bring admirers and admirees into closer range.

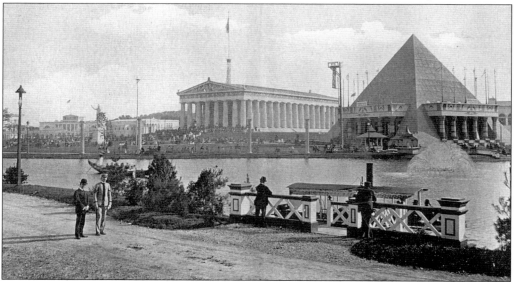

ACROSS LAKE WATAUGA. Coming back to the main walkway, pause a moment to look north. The Memphis Building, the Parthenon, and the entire north end of the grounds appear in this view. The Pyramid of Cheops, erected by the magnificent enterprise of Memphis and Shelby County and filled with a wonderfully attractive display, is the most conspicuous of the buildings not featured here. Next to Nashville, Shelby County was the largest contributor to the exposition's building, giving the sum of $25,000 for her display. The Pyramid was never uninteresting.